Realistic
Oil Painting
TECHNIQUES

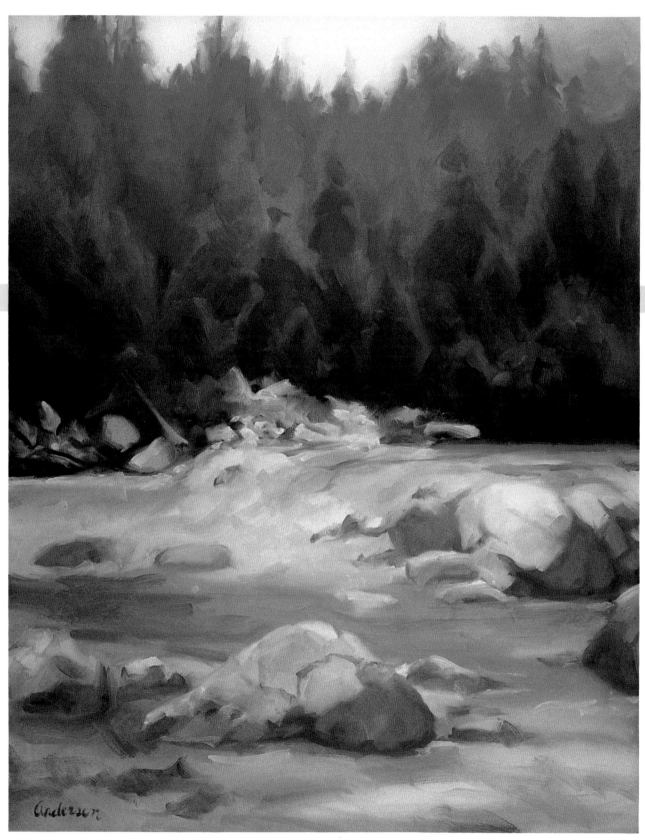

Rocky River, 28" × 22"

Realistic Oil Painting
TECHNIQUES

Kurt Anderson

NORTH LIGHT BOOKS
Cincinnati, Ohio

About the Author

Working out of his studio in St. Paul, Minnesota, Kurt Anderson is known mainly for his realistic oil paintings of genre scenes, portraits, landscapes and still lifes. His commissions have ranged from painting book covers to portraits of corporate presidents and religious scenes for churches. He has exhibited in galleries across the country from Nantucket, Massachusetts to Carmel, California. He has also exhibited in numerous museum shows, including the national touring exhibition "Classical Realism: The Other Twentieth Century." Other museum exhibitions include "The Academic Dialogue" at the Minneapolis Institute of Arts, and "The American Still Life" at the Minnesota Museum of Art. He has also received numerous awards, including the Stacey Foundation Scholarship for artists and the New York Salmagundi Club Award for figure drawing.

Kurt's writing and artwork have been widely published. For four years he served as editor of *The Classical Realism Quarterly*, and he currently serves as a contributing editor to *The Artist's Magazine*. His articles on painting theory and technique have appeared in these and other books and magazines.

Born and raised in Cedar Falls, Iowa, Kurt Anderson received most of his artistic education in the traditional atelier, or studio system of training, under Minneapolis artist Richard Lack. This makes him part of a master-pupil lineage that can be traced back to such nineteenth-century masters as Jacques-Louis David.

Realistic Oil Painting Techniques. Copyright © 1995 by Kurt Anderson. Printed and bound in China. All rights reserved. No part of this book may be reproduced in any form or by any electronic or mechanical means including information storage and retrieval systems without permission in writing from the publisher, except by a reviewer, who may quote brief passages in a review. Published by North Light Books, an imprint of F&W Publications, Inc., 1507 Dana Avenue, Cincinnati, Ohio 45207. 1-800-289-0963. First edition.

The *Mercury* cast drawing shown on page 12 is reprinted with permission of the artist, Paul G. Oxborough. All other artwork is done by Kurt Anderson; © Kurt Anderson.

99 98 97 96 95 5 4 3 2 1

Library of Congress Cataloging-in-Publication Data

Anderson, Kurt
 Realistic oil painting techniques / Kurt Anderson.
 p. cm.
 Includes index.
 ISBN 0-89134-576-0
 1. Painting—Technique. 2. Realism in art. I. Title.
ND1500.A53 1995
751.45—dc20 94-12941
 CIP

Edited by Rachel Wolf
Cover and interior design by Angela Lennert

METRIC CONVERSION CHART		
TO CONVERT	**TO**	**MULTIPLY BY**
Inches	Centimeters	2.54
Centimeters	Inches	0.4
Feet	Centimeters	30.5
Centimeters	Feet	0.03
Yards	Meters	0.9
Meters	Yards	1.1
Sq. Inches	Sq. Centimeters	6.45
Sq. Centimeters	Sq. Inches	0.16
Sq. Feet	Sq. Meters	0.09
Sq. Meters	Sq. Feet	10.8
Sq. Yards	Sq. Meters	0.8
Sq. Meters	Sq. Yards	1.2
Pounds	Kilograms	0.45
Kilograms	Pounds	2.2
Ounces	Grams	28.4
Grams	Ounces	0.04

To my parents,
Peg and Karl
and to my wife,
Arlene

My thanks to Greg Albert,
Rachel Wolf and all the editors
and staff at North Light Books
for their help and interest.

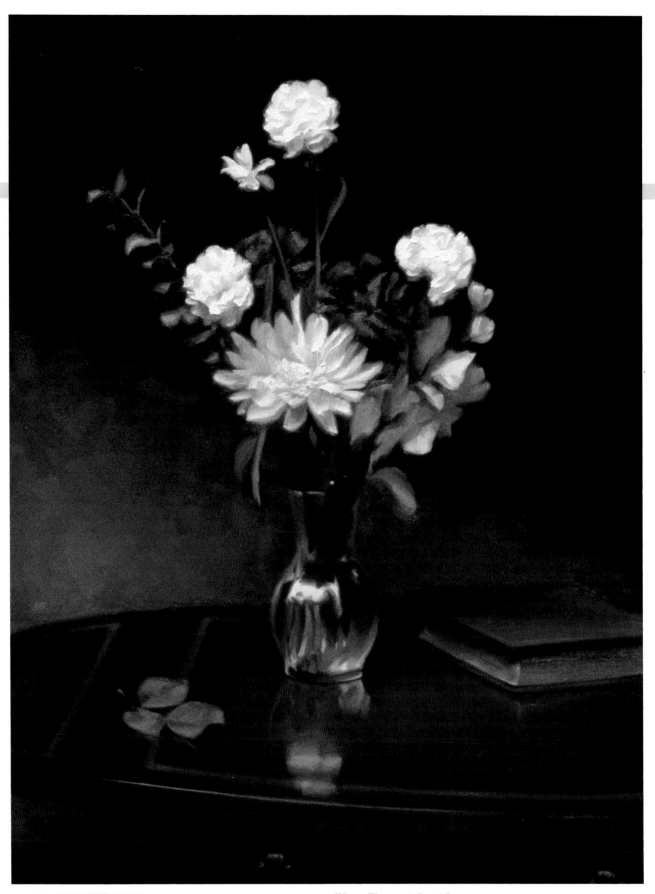

Winter Flowers, 24″ × 18″

Contents

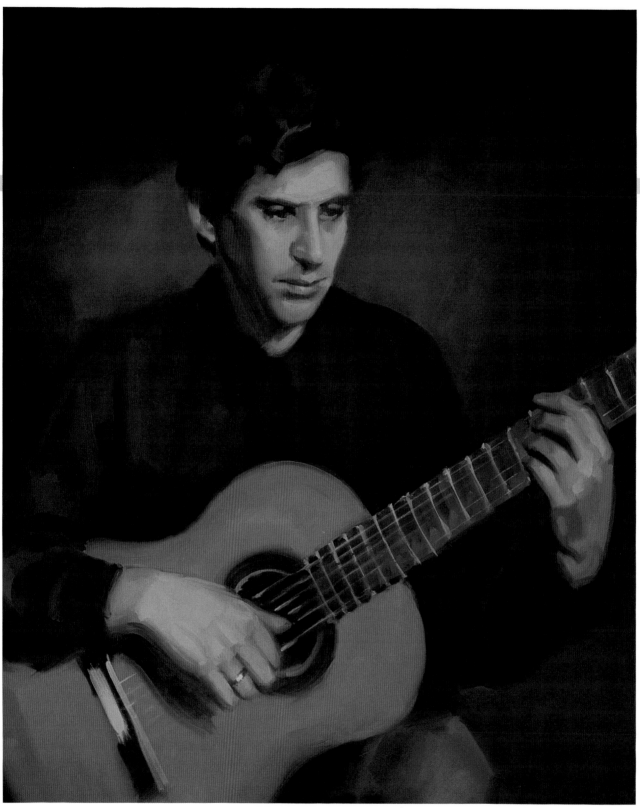

As I painted his portrait, this guitarist would sometimes practice his instrument. While most musicians take it for granted, I think that a lot of artists forget that you cannot have true "freedom of expression" until you have mastered your discipline as a craft, and that can take a lot of rote practice.

Portrait of David Crittenden, 28" × 23"

Introduction

"Art will never come except from some small disregarded corner where an isolated and inspired man is studying the mysteries of nature." This statement by Jean François Millet, one of my favorite artists of the nineteenth century, has always struck me as especially significant for artists today. It goes a long way in explaining what I feel is important as an artist. Like a great many other artists, I have felt the need to separate myself from the fashions and theories that pervade the art world and become reacquainted with the mysteries of the visual world.

It is a story that has been frequently played out in the history of Western art, and it is best told by Millet's own example. After studying in Paris and pursuing his career there for several years, this deeply religious man realized that he wasn't painting the things that were true to his heart. He was trying too hard to follow the fashions, trying too hard to be sophisticated. So he moved to a cottage in a rural area and immersed himself in a study of what he saw. He delighted in capturing the nuances of light and shade, of color and atmosphere. He painted the landscape and the peasants who lived around him. These were the people he had grown up with. Their daily activities were what stirred his soul. And in searching for the essential form to portray what he saw, his paintings express tremendous insight and depth of feeling.

LETTING NATURE PAINT ITSELF

Although my paintings are very different from Millet's, it is his example that has inspired me. I delight most in painting the people and things I see around me, and which I know best. I have also found that the careful observation and study of the visual world has unlocked the secrets of drawing and painting. My greatest breakthroughs as an artist have come as I have learned to rely more and more on nature to solve the problems in my artwork, and less and less upon myself. If what I'm saying seems obscure, let me give you an example.

When I first began to draw portraits, I would carefully examine the model and then begin to draw, pretty much the way I do now. However, I found that as soon as I put something down on the paper I would become obsessed with correcting the problems that I saw there. If, for instance, the eyes weren't lining up, all I cared about was getting them back in line before anyone else saw the drawing. My focus was on correcting problems with the drawing, and this would distract me from the model. So as the portrait progressed, I would find myself looking less and less at the model and more and more at the drawing. By the time I was at the finishing stage, the drawing and the model had diverged to an enormous degree, but I was always somewhat confused as to why.

The drawing was not nearly as good as it could've been because it was too precious to me. The drawing, not the subject being drawn, was too much the focus of my interest. If I had forced myself to look more at nature than at my drawing, they would never have diverged as they did. As I have learned to give more attention to what it is I am drawing or painting, rather than the artwork itself, my work has markedly improved. It is a process in which the act of painting becomes more and more an automatic extension of the act of seeing. This process I call, "letting nature paint itself."

This is more than one of those vague aphorisms artists like to impress people with. It contains an important practical lesson, and it is this: We can rely upon nature to provide the solutions to most of the problems we face in drawing and painting. It is in learning how to unlock the great repository of nature

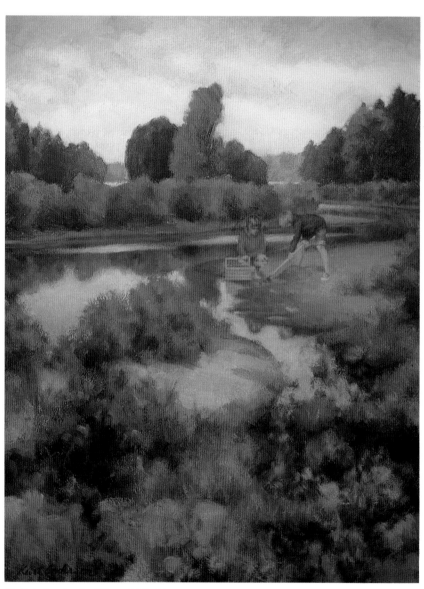

Delighting in the Visual World
Rather than worrying about the fashions that pervade the art world, I have spent most of my education studying the mysteries of the visual world. I delight most in painting the people and things I see around me, and which I know best.

Clam Diggers,
14" × 11"

that success in painting can be achieved.

Whenever I'm frustrated with a particular passage I'm painting, and find myself working over it again and again without satisfaction, I usually stop and tell myself, "Remember, let nature paint itself." Then, standing back, I look again at my subject and paint what it is I'm actually seeing. It may mean reworking a large portion of the painting that I thought was finished. But it's usually the only way out.

My personal direction as an artist is reflected, of course, in the make-up of this book. The phrase "radiant realism" would be one way to describe the sort of painting that I practice, an impressionism deeply rooted in the classical, narrative tradition.

But that doesn't mean that the lessons imparted here are limited to this style of painting. These lessons are not formulas. They are, more than anything else, observations about the nature of the visual world. The exercises in this book are designed to help us open our eyes, to translate correctly what we are seeing, allowing us to "let nature paint itself."

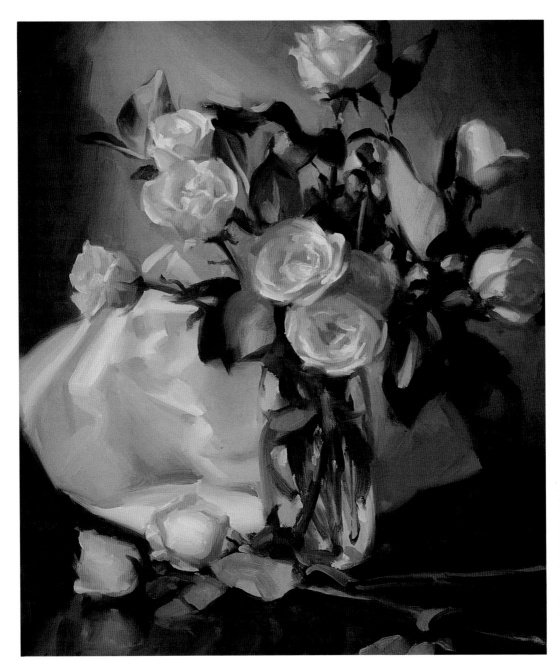

Act of Seeing
"Letting nature paint itself" is the process by which the act of painting becomes more and more an automatic extension of the act of seeing.

Still Life With Pink Roses, 24" × 20"

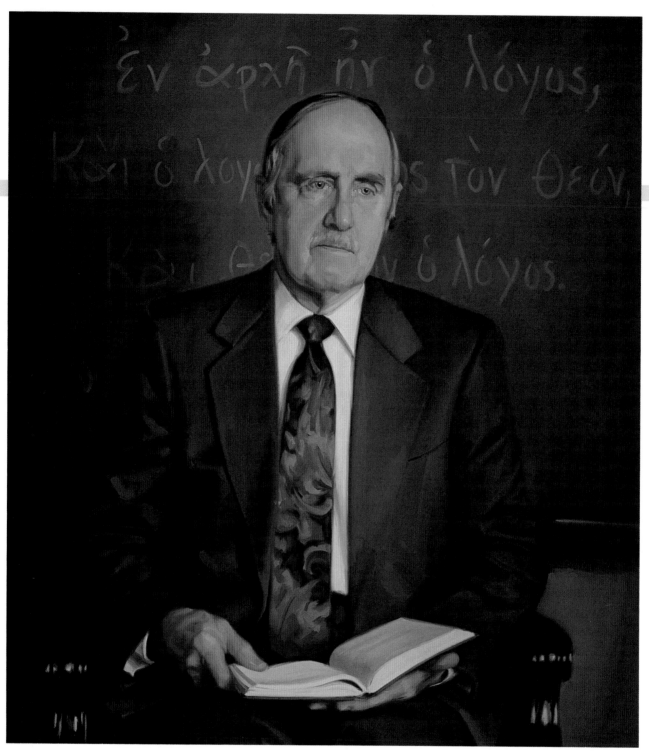

I wanted this portrait to capture the gentle, learned, pedagogical side of this author and professor, so I decided to use a chalkboard as a background. I painted a sheet of foamcore board the appropriate green. I gave him a piece of chalk and asked him to write something on it. He wrote the first verse from the Gospel of John in the original Greek, "In the beginning was the Word . . ."

Portrait of Walter Dunnett, 34″ × 30″

Building a Foundation

When I see a painting I admire, it is often because the artist makes it look so easy. The brushwork that looks so broad and haphazard up close, fuses together as I step back, and expresses perfectly the essential character of the scene. It is what the Spanish critics, in their discussion of Velázquez, called the *manera abreviada* — the ability to express maximum content with minimum brush-strokes.

One of the temptations I faced as a beginner was to try to emulate this broad, offhand manner of painting, but I invariably fell flat on my face. I think this is a temptation many artists have. We want to leap right in and express ourselves with the same freedom and spontaneity with which the Masters were able to express themselves. But this can have disastrous results. It is not, after all, the bold brushwork itself that is so admirable, but rather the fact that it describes so well all the essential elements of the scene. Without this foundation a painting will inevitably fail, and broad brushwork will only serve to make it look slipshod and crude.

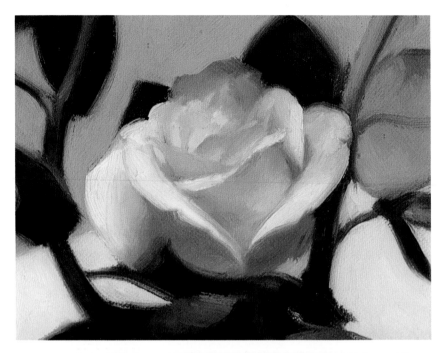

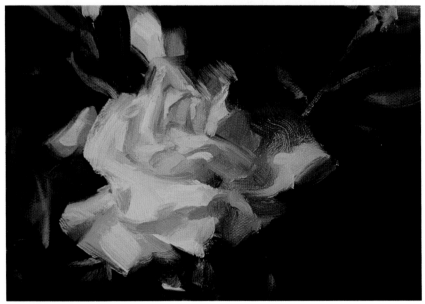

Developing Style
These two details of a rose show two different approaches to painting. The highly finished and refined pink rose (also shown on page 40) upholds a different aesthetic than the loose and expressively painted yellow rose (also shown on page 88). My painting technique has become looser over time as I have become more confident in my handling of the brush. That doesn't mean that I think one style is necessarily better then the other, but I do think that you must learn to render the visual world with careful accuracy before you can be more expressive in your technique.

A STEP AT A TIME

The virtuosity of the great masters is something that evolved over the years as they grew in their ability to translate what they saw into paint. One of the most distinct characteristics of the most virtuosic masters, whether we look at Velázquez, Rubens, Rembrandt or even John Singer Sargent, is that their early work is much more detailed and finished than their later work. In their early years they obviously couldn't capture what they saw as easily with their first touch to the canvas, but had to work over the painting several times. However, even without the deft brushwork, these paintings are enormously successful, as well as very personal. By working carefully and meticulously, they were able to capture what was essential in their interpretation of the scene. The virtuosic brushwork came later, as they grew in their confidence and skill. It adds to the effectiveness of their work but, as the earlier work shows, it is not essential.

I think it is therefore a mistake to put too high a value on "freedom of expression" when you are first learning to handle a stick of charcoal or a brush. You must first learn how to capture and express what it is you are seeing, and this often requires working very slowly and meticulously.

As in most disciplines, the skills involved in drawing and painting must be learned a step at a time with simple concepts and exercises laying the foundation for more complex ones. So in discussing the skills necessary for drawing and painting, I have found it helpful to examine some of the concepts and skills I acquired early in my career, and the methods by which they were learned.

A LEARNING EXPERIENCE

One of my earliest experiences was as a twelve-year-old taking drawing and painting classes at the local recreation center under the instruction of Mrs. Cook. I was a blank slate artistically when she began to teach me, so the impressions she made were deep. It was a long time ago, but the image I still retain is of a hardheaded woman full of practical, commonsense advice. Many of the most basic axioms of painting that I now utilize I learned at her hand.

One of the concepts she taught me was to use only the minimum number of paints and tools necessary to achieve the task at hand. She told us not to waste our money on any of the oil painting sets offered in the stores because we really didn't need that many different colors. She also thought that the fancy paint box was a waste since a shoe box could serve just as well.

So I went off to class every week with a shoe box containing four tubes of oil paint, a couple of brushes, a bottle of linseed oil and some rags. Proud as I was of that box, I look back now on its greater significance: With its few simple tools, it opened entire new worlds to me—worlds I eventually chose to spend my life pursuing.

But one of the greatest ironies is that it has only been in the last few years that I have come to rediscover the enormous potential and practicality of the four-color palette that Mrs. Cook advocated. It bemuses me to think that it was advice I had received at the very beginning of my education as an artist.

Although this early instruction was extremely important to my development, the experience that most deeply molded me as an artist was my four years of instruction in an atelier (pronounced ah-TELL-yea) which is French for studio or studio school, under the tutelage of a single artist, Richard Lack.

I first met Lack in 1977, while investigating alternatives to the university education I was at the time pursuing. I had come across an article about his atelier and decided it was worth investigating, so I traveled to his home and studio in the wooded suburbs of Minneapolis, Minnesota. When I first entered his studio, I was amazed to find myself surrounded by paintings that appeared to be by an Old Master. I had never realized painters were still painting like this, or were even capable of it. It was an enormous revelation.

Lack explained that he was part of a master-pupil lineage that could be traced back to eighteenth-century France. Lack had trained under R.H. Ives Gammell of Boston, one of the few artists who continued this tradition of teaching during the 1940s, 1950s and 1960s. Gammell, in turn, was a student under William Paxton, one of the more famous painters of the Boston school. Paxton had brought the tradition over from France after studying with the French academician Jean Léon Gérôme. I was convinced that day that this was the sort of training I wanted.

METHODS OF INSTRUCTION

Historically there have been three methods by which painters have passed on their knowledge to students—the apprentice system, the atelier system, and the academy or art school system. The apprentice system was the earliest and arguably the best method of training painters since it produced such masters as Michelangelo, Raphael and Rubens. However, not all artists needed apprentices to assist them in their work, especially after the sixteenth century when artists would often

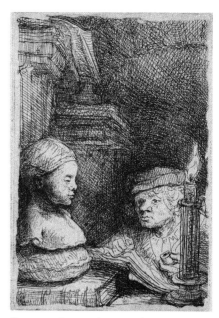

For several centuries one of the initial exercises for art students was to draw plaster casts of antique statues. Since a cast is completely white, it allows you to more easily observe how light and shade are affected by variations in the form, and since it is perfectly stationary you can more easily analyze the shapes.

Man Drawing From a Cast, Rembrandt van Ryn, 1641, etching.

gather protégés around them in what has come to be called an atelier.

It was during the seventeenth century that the atelier system began to emerge, and until the twentieth century it was the most common method of training painters. Rembrandt, Watteau and Chardin are some early examples of atelier-trained painters. Rembrandt himself ran an atelier, renting a warehouse for this purpose and dividing it into individual cubicle spaces for his students.

The third method of training painters is the academy or art school system (and their modern counterpart, the college art department). These kinds of schools are a departure from the other two methods of training painters since they involve

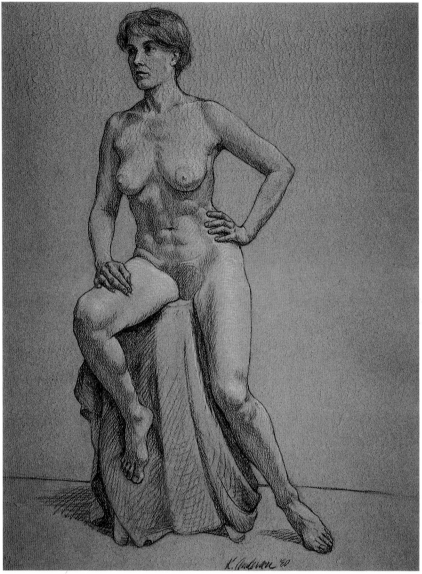

Charcoal Study
This is a figure drawing I did as a student using charcoal and chalk on gray-toned paper. We would frequently have the model assume the same pose for a dozen or more three-hour sittings. During that time, beginning students would make one or two drawings while advanced students would work on a painting.

from his atelier that a lineage can be traced, master to student, to some of the ateliers that survive today, including the atelier in which I trained.

THE ATELIER SYSTEM

In the atelier system it is by means of the highly structured and systematic curriculum that the craft is passed on from master to student. And it is on this curriculum that I am loosely modeling this book. As would be the case in an atelier, I will be presenting a series of artistic problems for you to master in a step-by-step process. The mastery of each artistic challenge lays the foundation for more complex ones. For example, since drawing is fundamental to painting, one of the first exercises I will introduce will be to draw from plaster casts of antique statues. Since a cast is completely white, it allows you to observe more easily how light and shade are affected by variations in the form, and since it is perfectly stationary, you can analyze the shapes more easily.

As a student at Atelier Lack, I spent a year working almost exclusively on such cast drawings. It was only when Lack thought I was sufficiently proficient at drawing that he allowed me to take up a brush. But at first I was only allowed to paint in black and white, and again I worked from casts because of their simplicity. I was lucky that before two years had passed, I was allowed to paint my first simple objects in color.

I mention this not only to show how seriously these exercises can be taken, but also to point out how this is very similar to the type of training artists in other disciplines receive. For instance, it is very common for musicians and dancers to put themselves under the tutelage of a single master. And it is taken for granted that they must begin their educa-

gathering together large numbers of students to study distinct aspects of painting in separate classes, each with a different instructor.

Although academies had been around since the sixteenth century they were sometimes controversial. In the eighteenth century the French Academie Royale was turn-

ing out painters who were thought at the time to be overly mannered in their drawing and style. It was in reaction to this that the great French master, Jacques-Louis David, championed a return to the atelier system of training. His atelier became a model for the ateliers of the nineteenth century, and it is

tion by learning fundamental skills, and must hone these skills through repetitive exercises and practice.

Unfortunately, in the visual arts this type of training was criticized around the turn of the century, when some of the impressionist and modernist painters complained about the tedium they suffered as students. I think they were mistaken about the real contribution this education made to their art. Nonetheless, the belief became widespread that the exercises in atelier curriculum served to inhibit spontaneity and creativity.

For this reason the type of curriculum found in contemporary art schools and college art departments often varies widely from the more traditional model. In drawing the human figure, it used to be the common practice for students to work for several days, or even weeks, from a single pose. Now it is not untypical for students to spend their entire education working from poses that last half an hour or less. It is also interesting to reflect that up until the 1930s and 1940s, almost all American art schools and colleges had a collection of antique statue casts for drawing instruction, but these have almost entirely been sold or discarded.

But it should also be pointed out that the atelier tradition has never been something set in stone either. Over the centuries it has changed, adapting the discoveries about the visual world that various masters have made. In the later part of the nineteenth century, for instance, the Impressionists opened up painters' eyes to the true nature of outdoor color. The Boston painters, from whom I've inherited the tradition, brought this to bear on the curriculum. They taught students how to reproduce the rich vibrating color that the eye actually sees and threw out the old color "formulas" that

Pencil Drawing
In the traditional curriculum, students first learn how to draw the figure by making small but highly refined pencil drawings. This figure study I made as a student is only about eight inches high. It was made using pencil leads of four different grades, each sharpened to a long tapered point.

artists had previously relied upon. As a result, artists like myself essentially teach the more impressionistic approach to painting explained in chapter three.

Although the curriculum may change over the years, and vary widely between different artists, its defining principle remains pretty much the same. It utilizes a building block approach to learning—an approach in which concepts are introduced a step at a time, with the mastery of each problem laying the groundwork for more complex ones.

A Program for Learning

What I am outlining is a program for learning. It is meant to be more than just a compilation of artistic concepts. It is also a method by which these concepts can, over time, be absorbed and added to your skill base.

I'm sure many will read this book to simply glean ideas here and there for application in their work, and I would encourage this. To apply these concepts in a practical way, however, may require that you work through some of the learning program as I outline it here. To improve drawing skills may require setting aside your paints and spending time drawing casts or other simple objects. Or, to better understand color, you may want to start painting small, quick color sketches, one after another, until they begin to show the richness and breadth seen in the work of the Impressionists.

There is, I think, one small danger involved in these exercises. You should not become too enamored of them. They should not become an end in and of themselves. I have

known artists to master the skill of making highly finished drawings and paintings, for instance, but who never move beyond that. They lose sight of the objective for which these types of exercises were designed—to achieve greater freedom of expression. Instead, their work remains dry and mechanical. It abides scrupulously by all the rules, but lacks the heart and joy of artistic expression.

I think the pitfall most artists fall into, however, is at the other extreme—self-expression without the fundamental skills necessary to achieve it. No matter how broadly or spontaneously you may desire to paint, you must first build a reserve of basic skills. But once you have those skills it is like being set free. That is when real self-expression and artistic fulfillment begin.

Learn From Landscape Sketching
Landscape sketching is an ideal way to learn how to capture the broad visual impression and the rich vibrant colors that are found out-of-doors. This type of exercise was added to the traditional curriculum by the Impressionists.

Iowa Farmstead, 9″ × 12″

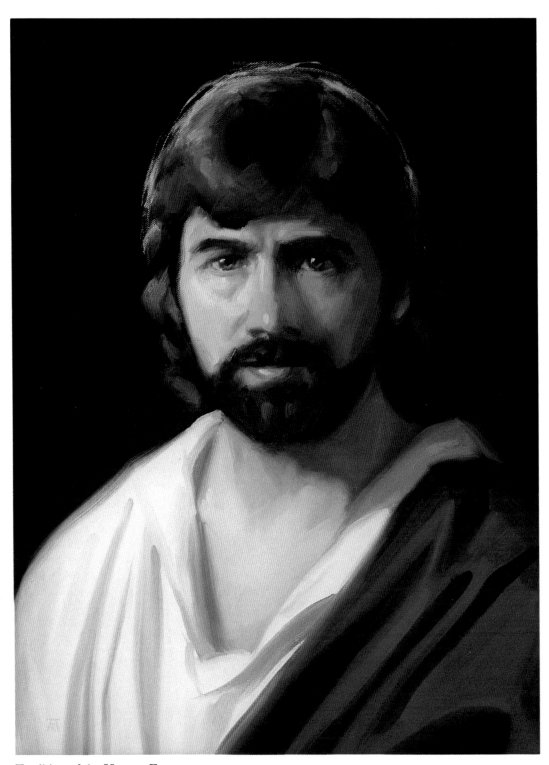

Tradition of the Human Form
The primary objective of traditional art training is to learn how
to paint the human form. Up until at least the mid-nineteenth
century, most art students aspired to be painters of historical,
mythological or religious subjects.

Christ the King, 20″ × 15″

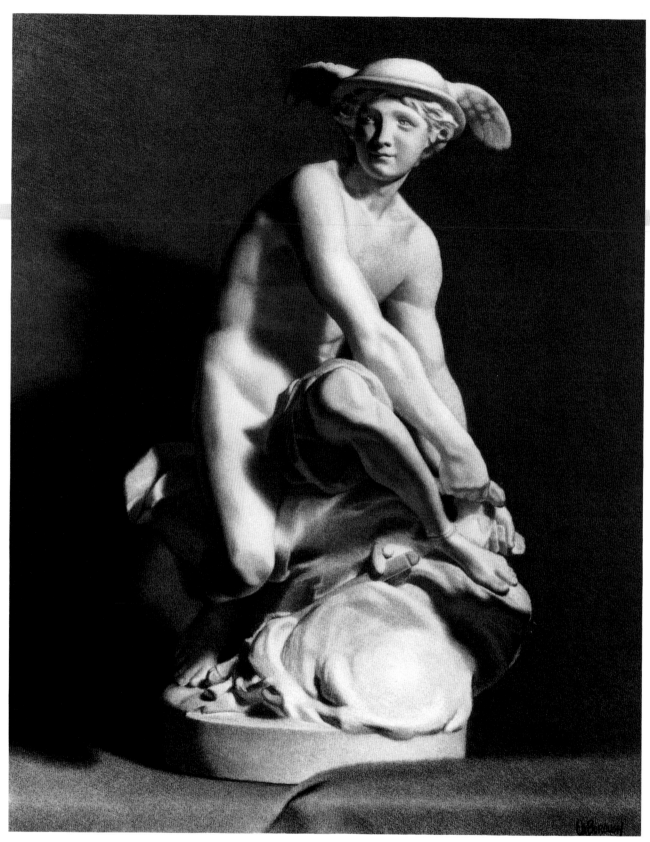

This *Mercury* cast drawing was made by artist Paul Oxborough when he was a student under me at Atelier LeSueur, a traditional studio school of art in Wayzata, Minnesota. He spent weeks working on this drawing, and it demonstrates the degree of finish and refinement that can be brought to such an exercise.

Cast drawing, 24" × 18"

The Mechanics of Drawing

There is a famous woodblock engraving by Albrecht Dürer that shows an artist looking at a portrait model through a pane of glass. He is looking through a stationary eyepiece, and he is tracing what he is seeing onto the glass. This simple device could be considered a sort of primitive camera. It allows the artist to transcribe the three-dimensional world directly onto a two-dimensional surface that stands between the artist and what he is seeing.

Learning to interpret the three-dimensional world in terms of two dimensions is the first and most basic lesson a painter must learn. And in large measure it is a process in which we learn to see the world as if through a pane of glass. What Dürer's artist was doing in a very mechanical way, we must do conceptually every time we draw.

SIGHT-SIZE METHOD

There are two important points to notice about Dürer's artist. The first is that he is looking at his subject from a fixed position. Obviously, if he observed the model from another position, the shapes, as they hit the glass, would change. The second thing to notice is that Dürer's artist is drawing the figure the exact same size as he sees it. If he wanted the drawing to be larger, he could move the glass closer to the model, and if he wanted it to be smaller, he could move it closer to himself. But in either case, he would still be drawing it the same exact size as he was seeing it.

Whenever you view a subject from a fixed position, and draw it the same exact size that it is seen, you are employing what is called the "sight-size method." When using this technique, however, artists don't normally draw on a pane of glass.

VIEWING POINT

When I paint a life-size portrait or still life, I always set up my easel just to the side of the subject. I then choose a point from which all of my observations will be made (the viewing point) — usually several feet back from the easel. From this fixed point, I can easily compare the subject and my painting in a single glance: both should appear the exact same size. As I hold an observation in my memory, I walk up to the easel and paint it, then I return to the viewing point to make another observation. This process is repeated from the first strokes of drawing through the final stages of modeling.

The great advantage of the sight-size method is that it allows for an easier comparison between your subject and your artwork and eliminates transposing the visual image to a different size as you draw or paint. This technique has been used by artists for centuries to help them paint with greater accuracy and ease. And it is an essential technique for learning the mechanics of accurate drawing.

Tracing Contours on Glass
In this woodcut by the German Renaissance master Albrecht Dürer, an artist uses the sight-size method to draw the contours of exactly what he sees through a piece of glass onto the glass itself.

Draftsman Drawing a Portrait,
Albrecht Dürer, 1525, woodcut.

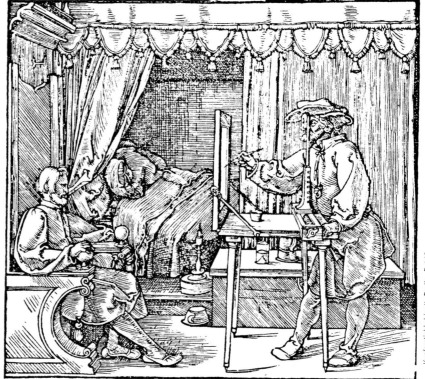

CAST DRAWING

During the 500 years that followed the Renaissance, young art students would almost always receive their first lessons by drawing plaster casts of antique statues using the sight-size method. Illuminated from the side by a single light source, the casts would be rendered through a series of charcoal or chalk tones. Students often spent several years "drawing from the antique" before they were allowed to advance to drawing the live model.

Since casts remain stationary, are solid white, and can be drawn from day to day under the same lighting conditions, they simplify the problems involved in drawing and modeling. Cast drawing is essentially an exercise, like practicing scales in music. The purpose of the exercise is to learn to render proportions correctly and to model the effects of light and shadow. These things are the foundation of good draftsmanship, and if they haven't been mastered in cast drawing, they will probably elude you when facing more complex drawing and painting problems.

Another helpful exercise is to draw simple still-life objects, such as earthen jars, plates and bottles. Such still lifes present some very different drawing problems which are also important to master. These problems include such things as relating a variety of objects to one another in proper perspective, and rendering straight lines, ellipses and other man-made shapes.

In my discussion of the general principles of drawing over the next two chapters, I will direct most of my comments to the cast demonstration. The principles of drawing I will be discussing here, however, are fundamental to anything you might draw or paint.

Drawing Subjects
The statue casts and earthen jars shown here are ideal subjects for learning the basics of drawing.

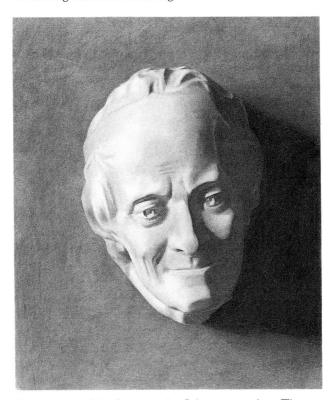

This was one of the first casts that I drew as a student. The cast was hung on a plywood board which I placed on an easel, while on another easel, directly next to it, I placed my drawing board. All of my observations were made from a point about five feet in front of the two easels.

Voltaire Cast Drawing, 15″ × 12″

SETTING UP YOUR SUBJECT

I like to use natural light from a window when I paint, but I think that spotlights often serve just as well when drawing. If you use a window, it is best if it faces north. The light from a north window is the most consistent since the sun will not shine directly into a north window at any time of the day. For the same reason an east window can be used for drawing in the afternoon, and a west window can be used for drawing in the morning. A south window is useless since the sun will continually alter the light. Only one window should be used so that you have a single shadow line, and I also suggest that you block off the lower part of the window so that the light falls from a more upward angle.

Spotlights are sometimes better for beginners, especially in cast drawing, since they create a nice, strong separation between light and shadow. I recommend using a 125-watt bulb, and setting up the light slightly above and to the side so that a quarter to a third of the cast is in shadow. The light should not be aimed so much at the cast but at the drawing board, which should be placed beside the cast on the opposite side from the spotlight. This will reduce glare on the cast and allow sufficient illumination for the drawing.

USING THE VIEWING POINT

In order to work sight-size, you must choose a single point from which all your observations of the subject will be made. You should be centered between the drawing board and your subject, standing far enough back from them so that the area being drawn can be seen in its entirety in one glance without moving your eyes from side to side. You should be close enough so that your field of vision does not encompass

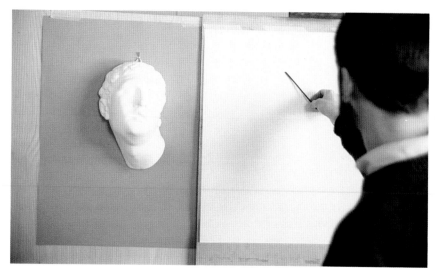

The Setup
The subject (plaster head) is set up right next to the drawing paper. The single light source is coming from one direction (the upper right) and illuminates the drawing paper as well as the plaster cast.

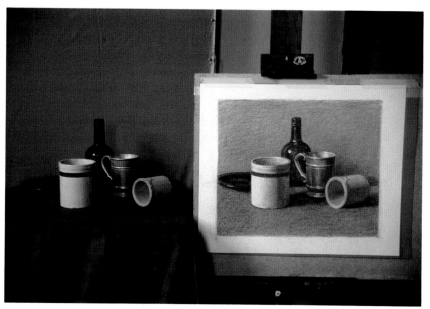

Viewing Point
By setting the easel next to the subject and standing back to make your observations, you are better able to compare the two. The viewing point should not change and as a rule the distance between the viewing point and your drawing is three times the greatest dimension of the drawing.

more than what you're drawing. This distance is usually three times the greatest dimension of the drawing. So, if the area of your subject encompassed in the drawing is, say, two feet, you should be making your observations from a point about six feet from the drawing board.

I should also add at this point that the sight-size method works best when the subject is at or near eye level. When drawing a portrait, or cast of a head, I like the eyes to be the same height from the floor as my own eyes. I tend to set up still lifes a little lower, but not so low that I have to stoop when I'm at the easel.

EASEL PLACEMENT

The size of the drawing depends on the placement of the easel relative to the subject being drawn, as well as where the artist stands in relation to the easel. A cast will almost always be drawn life-size, so the easel and drawing board are placed directly beside it. As a general rule, a greater part of the cast should be behind the drawing board than in front of it. For instance, if you were to stand by the side of your drawing board and look along the edge at a cast of a free-standing bust, the nose and chin would stick out in front of the board and the rest of the head would stick out behind it. This is also the practice I tend to use when working on a life-size portrait.

One other important point is that the drawing board should always be perfectly perpendicular to the line of vision. I imagine a straight line drawn from my viewing point to the easel. The front of my easel or drawing board should be at a right angle to this line. I find myself frequently readjusting students' easels because they fail to place them in the proper position, and as a result have slight distortions in their drawings.

THE USE OF CHARCOAL

Cast drawings are made using natural vine charcoal, which comes in a variety of grades, from extra soft

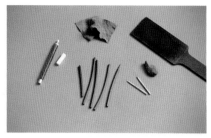

Basic Tools for Charcoal Drawing
Clockwise: a small chamois cloth, sharpening board, kneaded eraser, two paper stomps, five vine charcoal sticks and two pieces of chalk (a square piece and a round piece in a chalk holder).

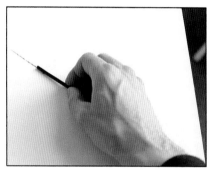

Using Charcoal
A good way to hold charcoal is between the thumb and first two fingers. Hold it close to the paper and pull it in the direction of the line you're drawing.

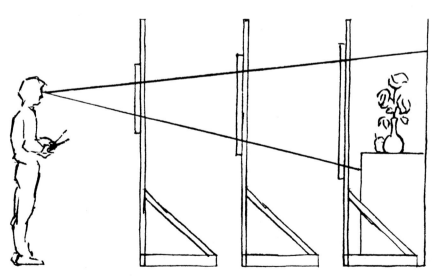

Sight-Size Method
Sight-size allows you to draw your subject in any size by adjusting the placement of your easel. These sight lines show that the subject will be largest on the canvas when the easel is close to the still life. The farther the easel is from the subject, the smaller it should be drawn. The smallest should be when the easel is at the artist's viewing point.

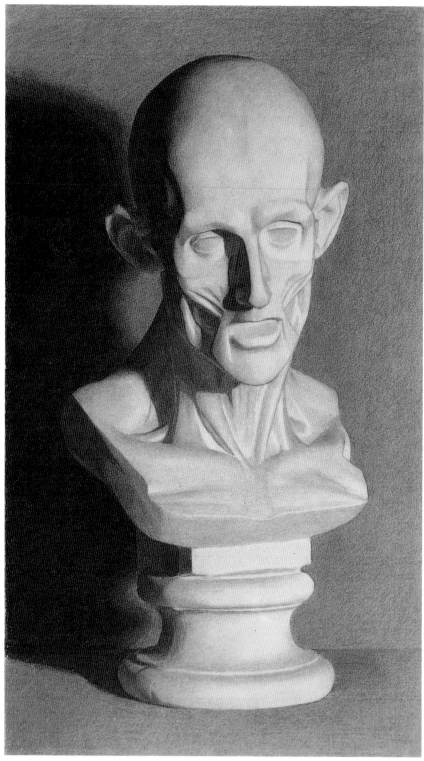

The process of drawing a cast is the process of continually correcting and perfecting what you've already put on the paper. This means that you need to use a high-quality charcoal paper, such as Canson Ingres, and that you should erase using a chamois cloth, to avoid distressing the surface of the paper.

Anatomical Cast Drawing, 24″ × 16″

to extra hard. I use a fairly soft stick when I begin the drawing. I advance from a soft grade to harder ones as I proceed, so that by the finishing stage I use only charcoal that is extra hard. The harder grades of charcoal I sharpen to a long tapered point. I do this by holding the charcoal stick flat against a piece of sandpaper and rubbing it back and forth while rotating it with my fingers.

The best way to hold a charcoal stick (especially when drawing contours) is between the thumb and the first two fingers. I hold the charcoal stick almost flat against the paper, forming about a 15-degree angle where the point meets the paper. I then pull the charcoal across the paper in line with the contour being drawn: that is, the length of the charcoal stick follows the same direction as the section of contour I'm drawing. This allows me to keep a light touch and to make a flowing, expressive line.

Most of my erasing is done using a chamois — not the kind you use for drying cars, but the softer kind available at art supply stores. I cut it into smaller pieces for easier handling. I use a kneaded eraser on those areas where the chamois does an incomplete job. The kneaded eraser is also good for gently lifting off charcoal in the modeling stage.

Cast drawings are made on white charcoal paper. Canson Mi-Tientes is the brand I used in the demonstration in this chapter, though I also recommend Canson Ingres. In both cases, it is best to use the smooth side. I tape it to the drawing board at the top only, so that it hangs flat. A few sheets of paper are placed underneath for padding.

THE PLUMB LINE

For artists, a plumb line is best made with a heavy black thread, about 1½ feet long, with a small weight tied at the end. It is used for

determining the relationships of shapes along a perfectly vertical line. When setting up the drawing board on the easel, the first thing to do is make sure that it is perfectly straight up and down by lining up the edge of the drawing board with the plumb line. When you first start a drawing, draw a vertical line on the paper using the plumb line or a T-square. When I began drawing the cast, this line divided it near the middle hitting the corner of the eye on the left.

MEASUREMENT POINTS

Before you actually start to draw a cast, it is important to plot several measurement points. Begin by plotting them along the vertical axis. To do this, hold the string of the plumb line horizontally at arm's length. A ruler may also be used for this purpose and some students even employ a ruler with a carpenter's level, using the bubble to make sure they are holding it perfectly horizontal. Standing comfortably at your estab-

lished viewing point and closing one eye, first mark the highest point and the lowest point of the cast, marking it on the vertical line (or to the left or right of the vertical line depending on where the points fall). Then mark several points in between, like the corner of the eye, line of the mouth, bottom of the chin, etc. As you do this, it is important to keep lining the cast up between the two original points that you marked since the slightest variation in your position and posture will change

where these points fall.

Next, establish some basic widths. This is done by holding the charcoal at arm's length and perpendicular (or at a right angle) to your line of vision. (A knitting needle is also handy for this purpose.) Close one eye and find a distance (the side of the head to the nose, for instance), relating it to the tip of the charcoal and the end of your thumb. Then, without bending your arm, swivel so that you face the drawing and plot the corresponding distance there.

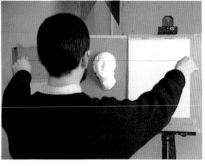

Measure With String
In order to draw the cast the exact same size that I see it, I use a string held horizontally to see where various points on the cast should fall on my paper.

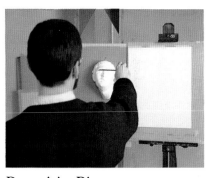

Determining Distance
When I want to determine the width between two points, I hold the charcoal at arm's length, close one eye, and line up the points between the tip of the charcoal and the end of my thumb. I then swivel to face the drawing and check the distance there.

Using a Plumb Line
With one eye closed, I look past the plumb line to see where points are falling along a perfectly vertical line, making sure they relate the same in the drawing as they do in the cast.

Plotting Measurement Points
I begin a cast drawing by plotting measurement points. Holding a string horizontally at arm's length, I mark where the top and bottom of the cast should fall on my paper, as well as several points in between, like the mouth, nose and eyes.

BLOCKING OUT

After I've established a few measurement points, I'm ready to begin drawing the outside contour. First, I simplify all the various curves and variations in the contour to as few straight lines as possible. This is called "blocking out" the contour.

An important principle of good draftsmanship is keeping your drawing as simple as possible while you work out basic shapes. By reducing all the complex variations in the contour to simpler, straighter lines, it's easy to rearrange them until their placement is right. You then have a superstructure that you can start refining with greater detail.

Putting down these first notations, however, can be enormously difficult. The most common problem beginners have is becoming too involved in one small part of the drawing, ignoring how it relates to the whole. And they frequently find that their contours have wandered way outside the boundaries that they already established with their measurement points. The challenge with the sight-size method is to keep your drawing the same exact size as you see it. So you can't start by drawing one detail of the subject and then make the rest relate to that detail. You have to keep the entire drawing at the same level of completion. That is the only way that you can make every detail relate properly to the whole, while making the whole a very specific, predetermined size.

It may seem, at first glance, that this is making the problem of drawing unnecessarily difficult. But developing this discipline is absolutely essential to sound draftsmanship. Only by keeping every part of your drawing at the same level of completion as it evolves will you have complete control of what the final drawing will look like.

To get started in the blocking-out stage, I just get something on the paper to indicate the important contours. A single line to indicate the basic gist of the right side of the head, another couple lines to indicate the main angles of the left side. The bottom of the neck can easily be translated into a single straight line, so I put that down. The top of the head is a little more complicated, but one or two lines at different angles are enough to convey the idea. Putting these first few lines down takes only a few seconds, but once they are down, I immediately start relating them to each other.

First, I check the width between the right and left sides of the cast. I do this by using the trick I ex-

Cast Drawing, Step One
To initially block in the contour and shadow line, I reduce the complex shapes to as few simple straight lines as possible. It is important to keep these lines within the boundaries I have already established with the measurement points. The vertical line on the paper serves as a guideline, dividing the cast in half.

THE SHADOW LINE

Since the cast is uniformly white and is illuminated by a single light source, any variation of value is caused by the angle at which the light rays hit the cast rather than variations in local value or color. Variations of value within the light (or non-shadow) area of the cast are called "halftone." The shadow area is where the rays of light miss altogether. Because of this, the line dividing the light and shadow areas is always fairly distinct. The halftone may be very dark in that area, but at some point the light rays hitting the cast at an oblique angle (forming halftone) miss altogether (forming shadow).

After blocking out the contour, you should similarly block out the shadow line, reducing all of its variations and curves to fairly simple, straight lines. Also, block out any shadows that are being cast on the wall or stand.

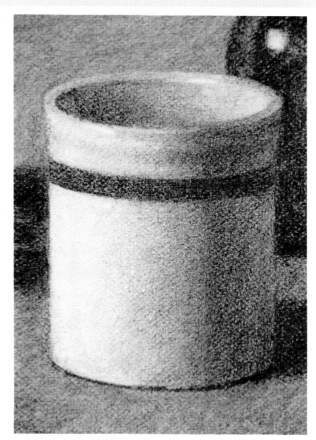

Straight Shadow Line Because this ceramic jar (from the still life on page 36) is perfectly cylindrical, the shadow line is a perfectly vertical straight line. Because the halftone is very dark where it meets the shadow, however, the shadow line is very soft. The only way to see whether the line is sufficiently straight while keeping it sufficiently diffuse is to see how it appears out of the corner of your eye.

plained earlier of holding the charcoal at arm's length and lining up points on the cast, in this case the outside contours, with the tip of the charcoal and the end of my thumb.

Next, I hold up the plumb line horizontally just as I did when I plotted the measurement points. Passing it down slowly over the cast, I see if points are lining up on the horizontal axis as I originally plotted them. I also note how the various contours of the cast form an angle with the horizontal line, seeing whether I achieved the same basic angles in the drawing.

Finally, I look at the vertical relationships. Holding up the end of the plumb line with one hand at arm's

length, I have a perfectly vertical line to see how points are relating to one another on the cast. I then face the drawing and compare the same points there. I also use this vertical line to observe the angles of the contours, just as I did with the horizontal line.

Although it has taken me a few paragraphs to explain all this, it doesn't really take a lot of time to work out the shapes at this stage in the drawing. More subtle problems in the shapes will become evident later. The techniques I just described should be used continuously to examine the shapes at every stage. But don't be overzealous in the blocking-out stage. Simply cap-

ture the basic shape and gesture while rechecking the placement of points, then move on to the next stage of the drawing.

MASSING IN

The next step is to solidly fill in the shadow with charcoal. This is called "massing in." I initially mass it in evenly with a single value. I strive for the value of nature (value that I see), though it is best at this stage to leave it slightly lighter than nature so that I can push it darker as I refine it.

I want to stress that I make the value fairly solid and even, simplifying all the variations of value within the shadow. However, there are

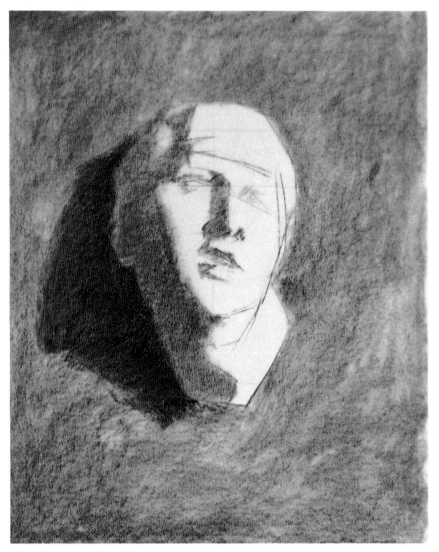

Cast Drawing, Step Two
The cast is initially massed in with four flat values. There is a value for the light area of the cast (the white paper), a value for the shadow on the cast, a value for the background, and a value for the shadow being cast on the background. I put these values down with the side of a soft piece of charcoal, and then smoothed them out with my thumb.

value differences between the shadow within the cast itself and the shadow cast on the wall or stand. These cast shadows will be massed in darker, since they're usually darker surfaces. After massing in the shadow shapes, I mass in the background. As with the shadows, I strive for a value slightly lighter than nature at first, and I keep it fairly even, ignoring extreme variations.

At this stage it's important to keep the values flat and even. There should be no gaps, for instance, where the value comes close to a contour. To put down these broad masses of value I often use the side of a short piece of soft charcoal. The value I initially put down may be a little darker than the value I want, but I then go over the area with the side of my thumb. This lightens it and evens it out.

If you want to work a little more meticulously, use a stomp instead of your finger. A stomp is a wad of tightly rolled paper shaped like a pencil. It is used for smoothing out charcoal. I prefer the small stomps, about ¼ inch in diameter.

So far in this discussion of drawing I have been approaching it much like the artist in Dürer's famous print. I have analyzed nature (what I've been seeing) somewhat mechanically so that it can be better comprehended and mapped out on a flat plane.

In the next chapter we will look at nature in terms of its broader unity. The mechanics I've just described are helpful in laying the groundwork of a drawing—the superstructure, so to speak. But it is in seeing the broader unity that you can best bring your drawing to completion. And so, after some futher instruction on seeing and drawing, the demonstration drawing of the cast continues on page 28.

DETERMINING SHAPES

As you push your drawing to greater finish, problems in the shapes become more evident. So you should continually recheck the shapes at every stage of your drawing. Following is an outline of the methods you can use to evaluate shapes. Every square inch of your drawing should be scrutinized in terms of each method.

Distances: Abstract distances can be determined by holding the charcoal at arm's length and perpendicular to your line of vision. Close one eye and find a distance relating it to the tip of your charcoal and the end of your thumb. Then swivel so that you face the drawing and check the corresponding distance there.

Vertical relationships: Hold up a plumb line at arm's length and compare each shape to what is directly above and beneath it.

Horizontal relationships: Compare shapes as they fall along a straight edge or string held horizontally.

Angles: Hold up a plumb line or a horizontal line and examine the angles that the contours in the subject make with these lines.

Negative shapes: Examine the shapes formed between or cut out by the objects represented.

Mass relationships: Look at the "potato shapes" (those abstract masses of value you see when you squint or throw your eye out of focus). Compare them in nature and the drawing by quickly examining one, then the other.

Gesture: Compare the general gesture or expression by "flashing your eye" between nature and your drawing.

Mirror image: Set up a mirror so that you can see both the drawing and the subject reflected on it, and compare them.

Anatomy: Use your knowledge of anatomy to determine whether the drawing adheres to the proportions you ought to find in the figure and whether the modeling correctly expresses the structure underneath the skin.

Perspective: Use your knowledge of perspective to see whether your drawing adheres to the rules of perspective.

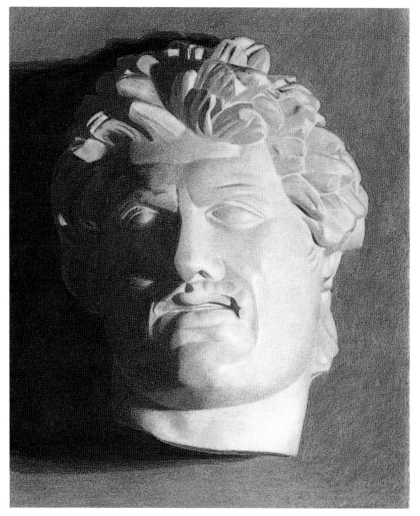

When you initially try to draw casts, it is a slow process. There is a whole list of things to look for, and you should be continually rechecking that list as you push the drawing to greater completion. Over time, however, this list becomes more and more a part of your skill base, and the process becomes much more automatic.

Lacoon Head Cast Drawing, 14″ × 10″

One of the biggest secrets to drawing is learning how to see things abstractly as broad masses of light and dark. Once those big values have been set down on paper, you can bring as much detail to the picture as you want, but it's surprising how little detail you actually need to make a very realistic portrait.

Portrait of Arlene Dedini Anderson, charcoal and white chalk on gray paper, 34″ × 28″

Drawing What You See

The French landscape painter Leon Pelouse once said that the gift of the naturalist painter lay in seeing the world as a newborn child sees it. Why? Because newborn children have no prior associations with the variations of light and dark and color that they see. Newborns don't know what shapes mean, or even that they represent tangible things. They don't know that trees are supposed to be green or tables flat. So if newborns were able to draw or paint, they wouldn't interpret what they were painting in any other terms than what was hitting the retina.

As children mature they learn that the shapes they are seeing represent tangible things. They develop associations, so that when they first start to draw, what they draw bears little resemblance to what is hitting the retina. Rather, it is their tactile response to objects that they depict. Heads are drawn as circles, arms and legs as elongated sausages, hair as a jumble of little lines.

OVERCOMING PRECONCEPTIONS

Even when we learn what shapes mean, these tactile associations that have become a part of us inevitably influence how we interpret what we see. In teaching students how to draw I always encounter the same errors, especially in depicting the human form. We are full of preconceptions about what the various shapes and colors of the human figure should be. Caucasians, we assume, are a fairly uniform pinkish beige. Our inclination is to paint lighter and darker variations of this color to define the form, just as it is our inclination to give length to an arm even when we may see it from a foreshortened perspective in which the arm's length is entirely hidden.

It also affects the degree of focus that we give the various objects that we are painting. We know that every portion of the subject we are drawing is equally tangible as any other, so our tendency to is to draw everything with the same amount of definition and detail.

It may sound ironic, but the secret to painting is learning to see what we are actually seeing. We have to overcome our preconceptions and associations. We have to become so detached from what it is we are drawing that we can see it fresh—as abstract shapes.

THE IMPRESSIONISTIC VISION

Striving to capture what is actually hitting the retina is the impressionistic vision. I explained earlier how the term "Impressionist" has come to describe a great many more artists in history than just the French Impressionists of the late nineteenth century. It's just that the French Impressionists carried this manner of seeing to one of its furthest extremes.

There seems to be a lot of confusion about this, so I should explain it carefully here. The great French Impressionists—artists like Monet, Sisley and Renoir—were not inventing colors from their imaginations. They were, in a way, as slavish to nature as artists have ever been. They delighted in painting the rich colors found in sunlit landscapes, so they invented a manner of painting called broken color, in which two dabs of color, of very different hue but like value, were put side by side. When seen from a distance, the eye would mix them, creating the same shimmering quality that sunlight has. That is why when you look at an impressionistic painting from a distance it is almost like looking out a window. The Impressionists were the first painters to capture what the outdoors actually looks like.

But broken color is only one small aspect of impressionism. Some of the concepts we now refer to as impressionism were understood and utilized by artists from at least the beginning of the Renaissance. The most fundamental of these is the idea of the "big impression."

THE BIG IMPRESSION

The "big impression" is based on this basic observation: No matter what you are looking at, only a very small point within your field of vision is actually in focus. Everything else within your field of vision is in various degrees of unfocus or obscurity.

Here's an easy experiment to do. Look at any object in the room—a doorknob, for instance. Without moving your focus from that object, note what else is in your field of vision. You should see a great many other things. You may see furniture, some close and some far away. What you should notice, however, is that the further these objects are away from your point of focus, the less real definition they have. This is es-

pecially obvious with those objects on the periphery of your field of vision. You know that they are there, but as the images fall on your retina they have little real substance.

One of the first artists to make this observation, or at least write about it, was Leonardo da Vinci. Looking at his paintings it may be difficult, at first, to see how he actually put the principle to use. All of his contours are clearly defined, all of the details are carefully rendered. What Leonardo understood, however, is that a painting had to have a center of interest, and that the details in other parts of the picture should not detract from the unity of the whole. In other words, when he looked at his painting he tried to see whether it had the same unity that nature has when it hits the retina of our eye. He achieved that unity in very subtle alterations of focus and composition, but he understood the principle and its use was essential to the success of his paintings.

By the late Renaissance, artists realized that they could take parts of their paintings out of focus, and they actually started to achieve unity in their pictures closer to the way the eye sees it. One could say that theirs was a tonal impressionism, since their color hues were often not very impressionistic—they used formulas and conventions in their colors that made them very unlike what the eye saw. The high watermark in this kind of impressionism was seventeenth-century Spanish master Diego Velázquez. What fascinated viewers at the time was that his pictures seemed so realistic from a distance, but at closer range the forms seemed to break apart into mere haphazard smudges of paint. More than any other painter, he had learned to see the world as abstract masses of light and dark, unencumbered by tactile preconceptions, as a newborn sees it.

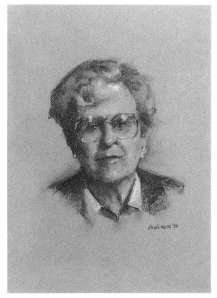

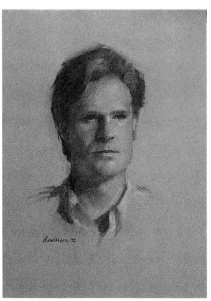

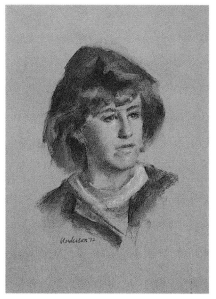

Quick Head Studies
In order to develop my skills at drawing "the big impression," I have made innumerable small head drawings of whoever I could get to pose for me. These are all examples—each about ten inches high. They were made on toned paper with charcoal and white chalk.

LEARNING TO SEE IMPRESSIONISTICALLY

There are a number of techniques that can be used to develop an impressionistic eye. In a sense, the most important technique is the sight-size method itself. The sight-size method forces you to make all of your observations for your drawing from a fixed point several feet in front of it, and this forces you to see the drawing as a unit. If your face is too close to your drawing when you make your observations, it is impossible to see how the various parts of the drawing are working together.

The sight-size method also allows you to see your drawing in direct relationship to the subject itself. By quickly comparing the drawing and the subject, flashing your eye between the two, it is easy to determine whether you have achieved the same unity in your drawing as you see in nature.

TAKE YOUR EYES OUT OF FOCUS

Another useful technique is to look at your subject without actually having any point in focus. There are several ways to do this. You can look at some point to the side of your subject so that you see your subject out of the corner of your eye. You can also squint, but that will alter the values of your subject. What I prefer to do is to simply take my eye out of focus, so that everything looks blurry.

When you do this you should see an abstract mass of value often referred to as the "potato shape." This is a very appropriate term. The objective is to see things so far out of focus that they appear no more recognizable than some oddly shaped vegetable. Only then will you be able to dispense with your tactile and color preconceptions and be conscious of what your eye truly sees.

If you have a severe astigmatism, taking your eye out of focus may be as easy as taking off your glasses. If your eyesight is good, however, it may be a skill you will have to cultivate. You can do this by holding a finger up in front of your face and focusing your eye on the finger. You will notice that everything directly behind it is out of focus. Now remove your finger without altering your point of focus. If you have trouble doing this you can leave your finger in place, holding it in front of whatever it is you want to observe out of focus.

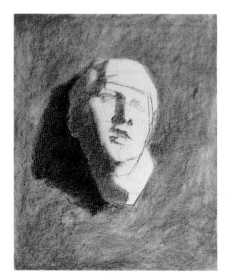

Cast Drawing, Step Two
As seen on page 22.

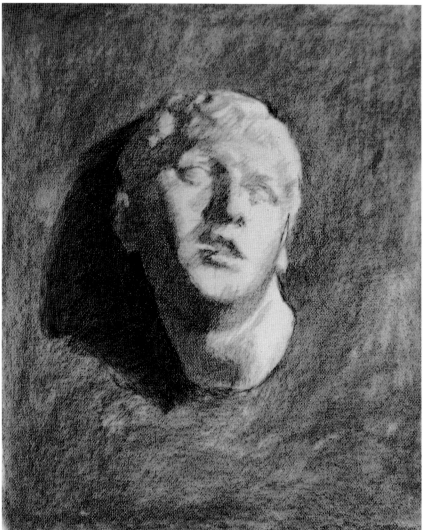

Cast Drawing, Step Three
Since the entire drawing is covered with at least some value, I can now analyze the shapes in terms of mass relationships. I put in the initial halftones, refine the shapes of the contours, and bring out some of the variations of value within the shadow. I avoid finishing any one small area, keeping everything at the same level of completion.

COMPARING MASSES

The practical application of the observation techniques I've just discussed comes increasingly into play after your drawing has been massed in. I left off on page 22 with a cast drawing comprised of four broad, flat values: one for the light area of the cast, one for the shadow side of the cast, one for the background, and one for the shadow being cast onto the background. This step is shown again above.

Now if I take my eye out of focus and look at the cast, it is these four basic masses of value I see. Since my drawing is defined very loosely by these four masses of value, I can begin to analyze my drawing in terms of mass. I look at each blob of value (or potato shape) separately in the cast and compare it to the same broad value in my drawing. It is easiest to compare them if I quickly flash my eye between the two. I can now correct the shapes in terms of the mass relationships.

HALFTONE

I'm now ready to begin massing in the halftones—variations of value within the light area of the cast.

Unlike the outside contours and the shadow lines, I cannot block out (or outline) halftone shapes. That's because they have no definite outlines. One halftone shape melts into another, usually by imperceptible degrees.

That is why I only begin to put halftones in at this stage. It is easy to get lost with the shapes, so I want as many reference points to work with as I can get. But what is important in initially putting down halftones is not so much the subtleties in the shape, but the proper relationships of the values. It is best to first mass in the darkest areas of halftone and work towards the lighter areas.

In nature, I continually compare the darkest halftone areas with the

lightest areas, and try to achieve a similar contrast between the two in my drawing. Since I can't draw with light, I have to work in a darker value range, pushing my darkest halftones darker. How dark I decide to push these values is somewhat a matter of taste. However, I discourage students from trying to achieve the full value range of nature in halftones. For one thing, it's almost impossible to do. While you may be able to push the halftones dark enough, there is a limit to how black you can make the shadows. Because of this, the contrast between the shadow and halftone area is lost. So compromises have to be made.

I have found, however, that students tend to make their halftones too light. Be sure to push them dark enough to capture the luminous quality of nature. The secret to doing this is glancing quickly between the value you're trying to draw and the lightest value in nature (what will be uncovered white paper in your drawing), and then pushing the value dark enough to get the necessary contrast.

I also like to establish the halftone values fairly quickly, even if it means sacrificing neatness. This way, the value will be correct as I go through the process of refining the modeling.

MODELING

To "model" is to draw all the subtle variations of value that define the form. Once the basic values of the halftones have been roughed in, I begin to refine the modeling and soften the transitions in the shadow line. This is best done using a hard piece of charcoal sharpened to a long tapered point. It is actually with the point of the charcoal that I smoothed out the surface in my cast drawing, making the transitions more subtle. This is a fairly painstaking process of filling in the gaps in value by slowly working over the surface with short back-and-forth strokes.

To keep my hand steady I use a *mahl stick*. I use a ½-inch dowel rod, about three feet long. Holding it in one hand and leaning it across the edge of the drawing board, I can rest my drawing hand on it to keep it steady.

Achieving just the right degree of modeling is difficult. The tendency is to exaggerate the variations in form ("overmodeling"). You must see the big impression to avoid this. One suggestion is to focus your eye on an area of the cast just to the side of the area you're drawing. You want to avoid "looking into it" because you will invariably see the transitions as being more extreme than they actually are in relation to everything else.

A second suggestion is to make your critical observations of the drawing from your viewing point. While you're at the drawing board you're too close to evaluate correctly what you've just drawn. Modeled areas that look correct up close will be too hard and extreme when observed from the viewing point. In the same way, areas of modeling that look correct from the viewing point will generally look soft and diffuse up close.

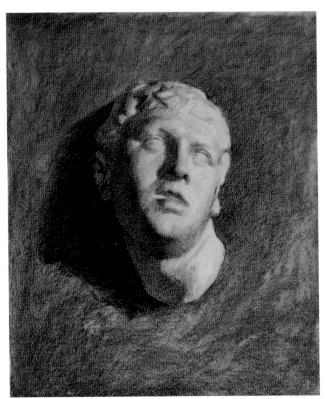

Cast Drawing, Step Four
At this stage I refine some of the subtle shapes within the halftone, pushing the halftones darker to achieve the value range of nature. I also refine the contours and the shadow line, especially where the shadow line is broken up into the myriad little shapes that define the hair.

DEFINING THE CONTOUR

With the same sharpened charcoal, the next step is to search out the subtleties in the outside contour or edge.

I focus my eye somewhere in the center of the cast and observe how sections of the contour appear in relation to the rest of the contour. Some parts appear well defined while others appear soft or "lost." With those sections of contour that I observe as "hard," I draw the outline of the contour with a single searching line. I allow the contour to be blurry where I perceive it to be soft. I then do the same with the shadow line and many other edges formed within the drawing. I render these edges not as they appear when I look right at them, but as they appear out of the corner of my eye.

ACCENTS

I try to achieve as much variety in the contour as possible. Some portions of the contour are darker than other parts, especially where the contour turns away from the source of light or overlaps another contour. In some places they will form hard points of shadow that are called accents. Looking at the cast as a unit, I observe where I have the darkest, hardest notes of shadow and put them in my drawing. A few well-placed accents can bring a flat-looking drawing to life, making it appear more three-dimensional.

HIGHLIGHTS

The brightest points in the cast, where the light rays reflect directly into the eye, are called highlights. On highly reflective surfaces, these highlights will be somewhat the same shape as the light source. If you are working on white paper, the highlight will take the value of the bare white paper. Since this is the limit of how bright you can go, the highlights in your drawing may have to be much less pronounced than in nature.

Highlights become much more obvious and effective when working on toned paper, as in the head drawing demonstration on pages 37 to 38. In that case the highlights are represented by the white chalk. In fact, that is pretty much all that the chalk is used for. The halftone is almost entirely modeled with the charcoal. I only employ the chalk to place in the final highlights, bringing the drawing into stark relief.

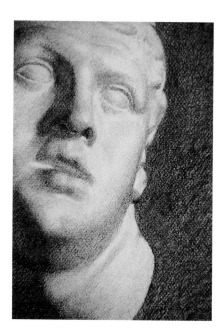

Detail— Showing Accents There is a great deal of variety in the contours on the light side of the cast. Also notice that there are hard points of shadow, called accents, that I have brought out in some places where contours overlap (beneath the ear) and wherever the shadow has an abrupt intersection with the light area (beneath the right nostril).

REFLECTED LIGHT

Reflected light is light that has bounced off other surfaces and back into the shadow. These variations are easy to exaggerate, and that is why I emphasized earlier that I like to first mass in the shadow shape with a fairly even value. Once I have the halftone values established, however, I then search out shadow variations more carefully.

I never actually look into the shadow, but to the side. I continually squint to take my eye out of focus, so that I won't be confused with detail. Since charcoal drawing provides a narrower value range than nature, I find that I must mute the variations within the shadow. I don't compare the reflected lights to the surrounding shadow area, but rather to the values throughout the drawing. Just as the value range in the drawing is narrower between the lightest and darkest halftones, the value range is narrower within the shadow as well.

BACKGROUND

The background in a drawing is always subordinate to the subject of the work. Therefore, I determine the background's value primarily as it relates to the subject. In drawing a cast you will observe that the background appears much darker where it meets the lighter portions of the cast, and in the same way it appears much lighter where it meets the shadow side. Logic tells you that the background is of a much more even value than it appears behind the cast, but I always ignore logic and draw what I see. The brain will register these variations as the logical effect of the very glow I am trying to achieve.

THE FINISHED DRAWING

A successfully finished drawing is characterized by four things. First, the shapes should be rendered well enough that as you flash your eye between the subject and your drawing, you can perceive no difference in the size, the gesture or the expression.

Second, the drawing should appear three-dimensional. In drawing a head, or a cast of a head, there should be a strong separation between the various planes of the face.

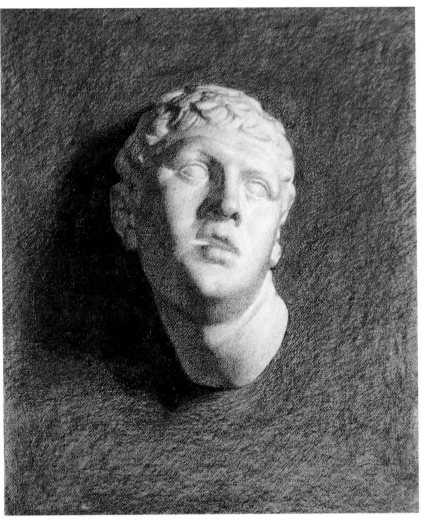

Cast Drawing, Finish
To bring the drawing to completion I used hard-grade charcoal, sharpened to a point. Working it back and forth over the paper, I softened and refined all the subtle variations in the form. The paper stomp also comes in handy at this stage for smoothing out the charcoal, and I sometimes use my kneaded eraser, kneaded to a point, to pick off charcoal and smooth out transitions.

LOST AND FOUND EDGES

Notice how the outside contour of the jar on its side is defined by the values behind the jar. Where the light area of the jar meets the background there is a strong contrast, and thus a strong contour, especially along the top. Along the right side of the jar, however, there are places where the value of the jar and the background are the same, and the contour almost disappears altogether.

Detail of still life as seen on page 36.

If there isn't, then the halftone should be reexamined and differences in values between these planes should be rendered.

Third, when the drawing is observed out of the corner of your eye, it should have the same sense of unity as the subject has in nature when similarly observed. If contours and transitions in your drawing seem harder, then it's overmodeled.

Finally, there should be a feeling of light and luminosity in your drawing. If it looks pale and washed out, it means the values in general haven't been rendered dark enough. If it looks muddy and brackish, it may mean the values are too dark, or the halftones may have been poorly observed or overmodeled.

As you continue to hone your skills at drawing, you will find that the more mechanical aspects of drawing described in chapter two, such as plotting measurement points and blocking out a superstructure, are more and more quickly completed, and you quickly get to the big impression stage of the drawing. When you reach this stage, you may want to try some more advanced exercises.

I made enormous breakthroughs with my own drawing skills after spending many months making numerous one- to two-hour drawings of heads. Although the basic principles I have been discussing are best learned by working on the more meticulous cast and still-life exercises, once these skills have been mastered, I recommend that you attempt exercises that force you to work more broadly and at a faster pace. Drawings made with charcoal and chalk on toned paper can be a more efficient and abbreviated method of working, and such exercises are helpful in developing an impressionistic eye.

Working at a fast pace forces you to draw very broadly, rather than in bits and pieces. It keeps you focused on what is essential to your subject — its unity — and it helps you avoid focusing too hard on the details. This is the crux of seeing the "big impression." And mastering this skill is an enormous step in learning to effectively draw and paint the visual world.

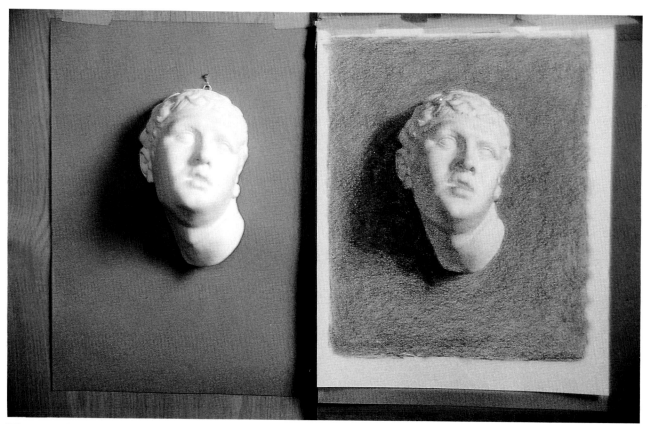

View and Compare
The sight-size method allows me to see the drawing and the cast in a single glance. Flashing my eye between the two, I can easily see any differences in the shapes and values.

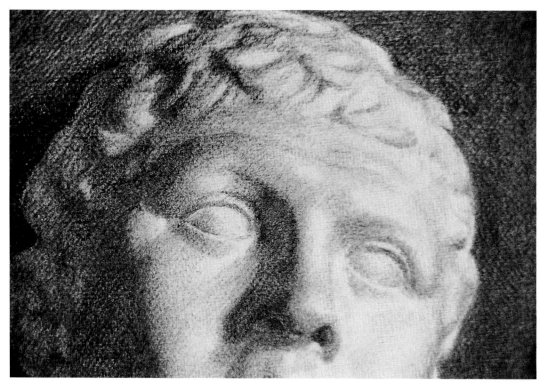

Detail — Showing Shadow Contours

Notice that the shadow line is broken up quite a bit in the hair area of the cast, and it takes an unexpected lurch in the forehead area because of the furrowed brow. Nonetheless, the contour of each shadow shape must be carefully searched out and defined in these places. A well-defined shadow line gives a drawing much more solidity and three-dimensionality than careful rendering of the halftone variations.

Detail — Showing Shadow Variations

The shadow is darkest where it meets the light. Reflected light increases as the form turns away from the light. You will notice that the contour on the shadow side is fairly soft or lost. It is especially lost where contours overlap, like where the neck meets the chin.

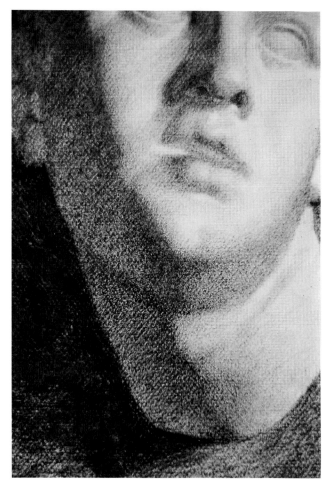

Still Life Drawing in Charcoal

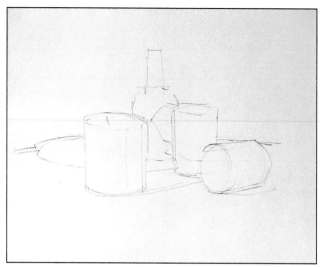

Plot Measurement Points
Using a string held horizontally in front of my face as a guide, I plot several measurement points representing the top and bottom of each object in the still life.

Step One — Block in the Contours
I quickly block in the contours of the objects. I find the widths by holding a piece of charcoal in front of my face and lining up the outside contours between the point and my thumb.

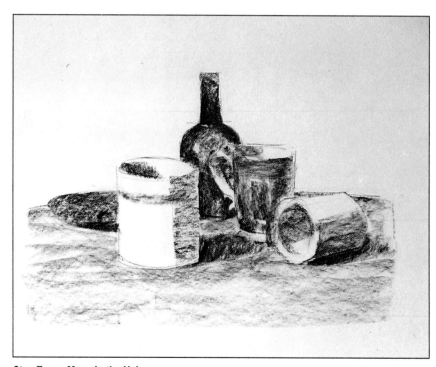

Step Two — Mass in the Values
This shows the drawing when I initially start to mass it in with the side of a soft piece of charcoal. Once I get the paper covered, I even out the values by rubbing it with my thumb.

Step Three — Analyze the Values
I like to get the drawing quickly covered with even masses of value so that I can start to analyze it in terms of mass. I take my eye out of focus so that I can compare it to the same blobs of value in the still life.

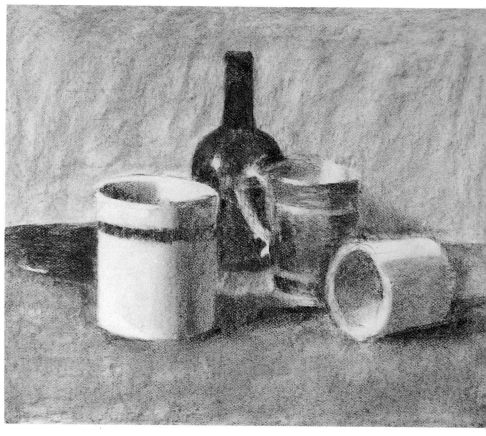

Step Four — Refine the Shapes
I spend a good deal of time at this stage pushing the values darker and refining the shapes. I refrain from putting down any more halftone or detail until all the objects relate properly to one another.

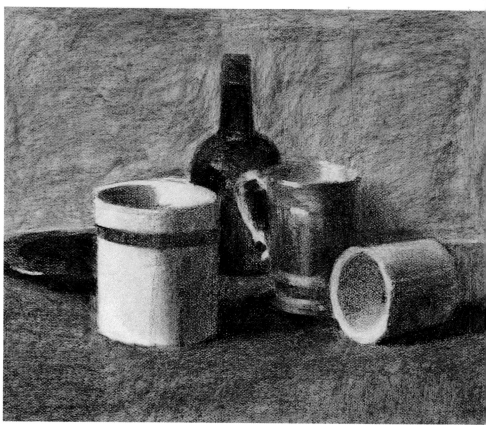

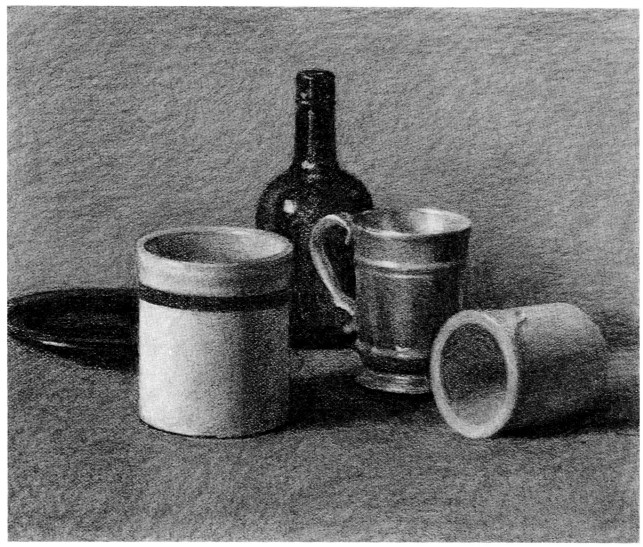

Finish—Model the Halftones
To bring the still life to completion I carefully model the halftones. Most of the finishing work is done using a sharpened stick of charcoal, though I also make ample use of a stomp to even out the values.

Head Drawing in Charcoal

Plot Measurement Points
I started the head drawing by plotting measurement points for the top of the head and bottom of the chin on a piece of toned paper. The line in the middle is where the eyes fall and the two lines beneath it are the nose and the mouth.

Step One — Start Broad and Loose
Notice how broadly and loosely I've initially blocked out the drawing. I don't bother refining these lines further because, until I've put down some values, I can't see the shapes anyway.

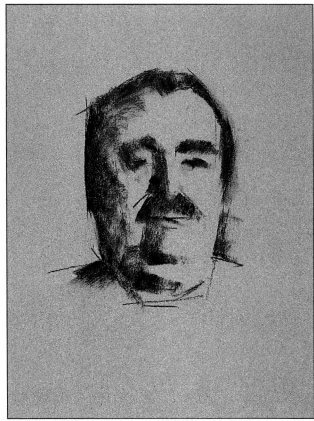

Step Two — Block in Shadow Mass
Using a piece of soft vine charcoal about an inch long, I quickly block in the shadow mass and the hair. This shows what it looks like before I rub it with my thumb.

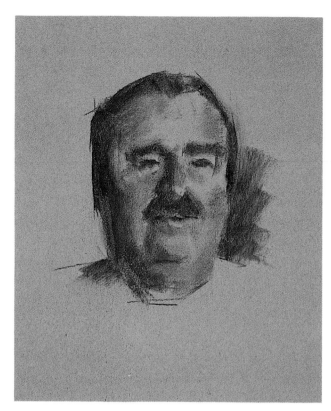

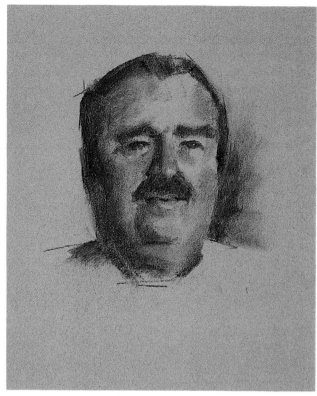

Step Three—Establish the Values

I unified the shadow shape and started putting in the halftone. The more values I establish, the more detail I bring to the shapes, though I try to keep everything at the same level of completion.

Step Four—Refine the Halftones

At this stage I concentrate mainly on refining the halftone area of the drawing. I also flash my eye between the model and the drawing to see whether I am achieving the same general expression and personality.

Finish—Highlight With White Chalk

I refine the drawing as far as I can using only the charcoal. At the very end I make use of the white chalk to drop in the highlights as a final touch in bringing the drawing to life.

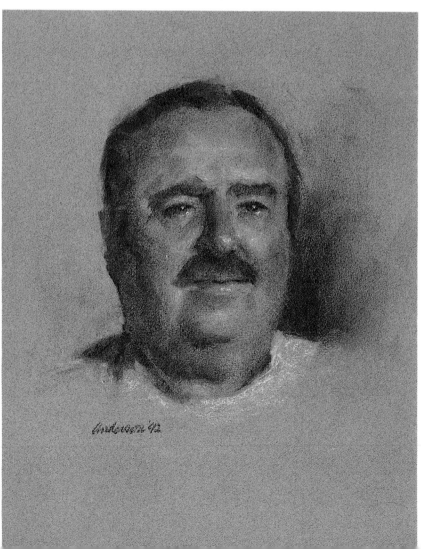

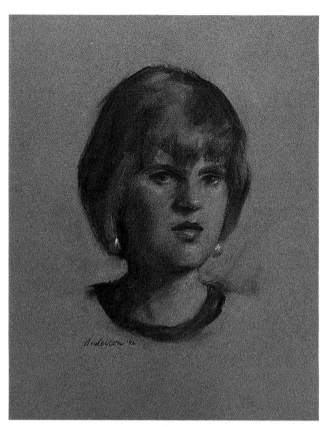

Quick Head Study

I think that the first response I have to what I'm drawing or painting is often the most compelling. That's why I like to work quickly, as I did with this small head portrait of Anette Abendroth. I allowed the first touch to the paper to stand as unaltered as possible.

Preliminary Studies

I don't often make preliminary drawings for portraits, but when I do it's often to capture my immediate response to the personalities of the subjects. When I was commissioned to paint the portraits of the daughters of Ann and Norman Strate, I didn't worry about perfecting my preliminary drawings (below). In fact, because I didn't have larger sheets of paper handy, I simply taped together the paper I had. I later regretted this because the drawings have a certain charm that make them stand on their own, even in their very incomplete state.

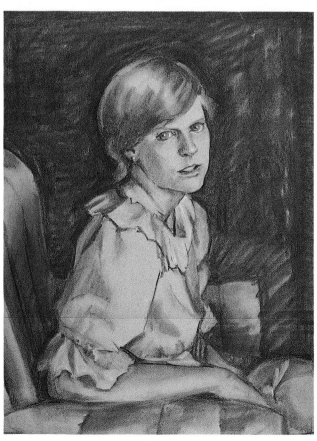

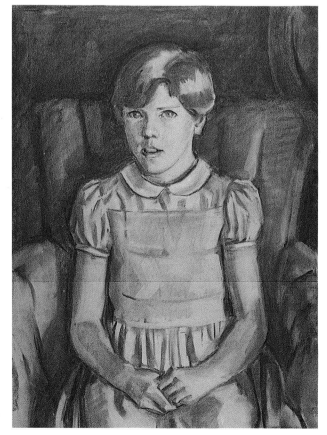

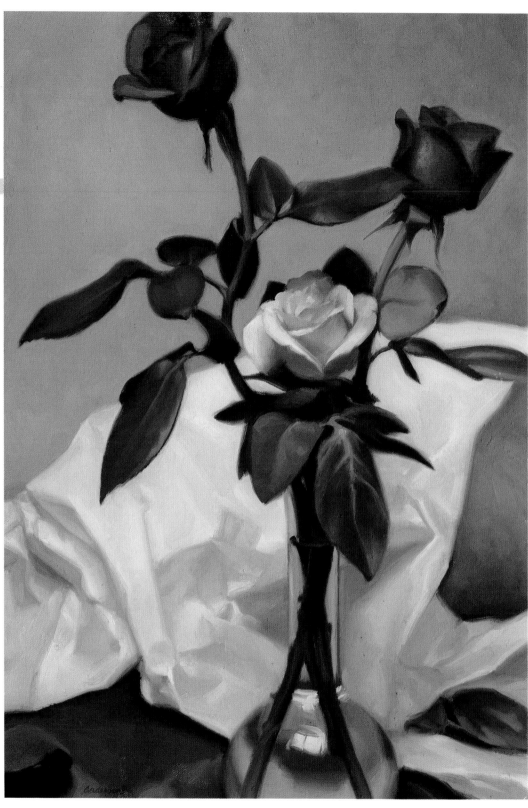

When first painting still lifes it is best to employ the "layered" method. You apply several successive layers of paint on the canvas, each layer improving upon the one beneath. This allows you to bring enormous control, refinement and detail to the finished painting.

Still Life With Three Roses, 14" × 19"

The Basics of Oil Painting

When people think of drawing they normally think of lines. There is, of course, a great tradition of drawing with lines, like the figure drawings illustrated in chapter one. However, I have purposely avoided discussing this type of "linear" drawing. The techniques I've been describing with charcoal are a form of "mass" drawing. With mass drawing the charcoal stick is simply a means of getting the charcoal dust onto the paper. Once it is there, it has the quality of being very fluid, more like paint than like something applied with a pointed instrument.

This is one of the reasons why charcoal drawing is an integral part of the traditional atelier curriculum. It is not uncommon for students in such schools to spend two years, or even more, drawing casts and the human figure in charcoal. Once a student has learned to see in terms of mass, and to handle charcoal as if it were paint, it is a small step to actually take up a brush.

If you were to ask me what the secret to painting is, I would have to tell you that I have already revealed the most important secrets in my discussion of drawing. The techniques that you can learn working with charcoal are the most essential to good painting.

THE ESSENTIALS

In introducing oil painting technique I am forced to digress from important visual ideas. The mundane must intrude upon our discussion, since you can't paint until you understand the uses and properties of all the materials and tools involved.

I mentioned in the first chapter that I first learned how to paint in oils as a twelve-year-old enrolled in a class at the local recreation center. I came to class every week with a shoe box carrying the barest essentials for oil painting which my teacher had told me to buy. I was a blank slate then, ready for whatever impressions my teacher wanted to make on me.

My own experience as a teacher, however, has been a little different from those children's classes. Usually my students are adults and they have already been purchasing oil painting supplies over many years. They sometimes come to class with great fishing tackle boxes full of partially used tubes of paint of every conceivable color. They also come to class with a multitude of questions and ideas about all the different theories of oil painting and techniques that they have heard over the years.

They ask me about one artist's fleshtone mixing system and about another artist's theory of tonal modification, and they are astonished when I reveal that I have never heard of a particular artist's treatise on mediums.

I sometimes walk away from these classes with a feeling that oil painting is a much more complicated discipline than I had realized. I am glad that at the age of twelve I was ignorant of all these theories and systems. Otherwise, I might have been too frightened of oil paints to even begin.

Of course there are so many systems of oil painting because every artist has very personal objectives for their art, and over time they develop very personal techniques for achieving those objectives. But for someone who is still a beginner, those systems and techniques can be more confusing than helpful. If you strip away the unessentials from those painting systems, the basic technical requirements for oil painting are really very simple.

GROUNDS

The ground is the actual surface on which an oil painting is painted. If oil paints are applied directly to untreated canvas or wood panel, over time the oil will be absorbed into the surface leaving the pigment behind in a very fragile state. By first applying a ground of glue or paint to these absorbent surfaces, you essentially seal them.

The traditional technique is to apply rabbit skin glue to the surface of the canvas, and then one or more layers of gesso (a thick white paint made of gypsum or chalk). Today acrylic gesso is often used as a ground for oil painting, since this does not require the initial step of treating the canvas with glue.

Most artists buy canvas which has already had a ground applied. This is referred to as "primed" canvas and is available with a traditional oil ground or an acrylic ground. Canvas referred to as double-primed has had two layers of gesso applied.

Canvas is available in two primary materials: linen and cotton. Linen fibers are longer than cotton ones, producing a stronger thread and a surface that is less likely to stretch and weaken over time. For a beginner, however, I recommend acrylic-

Stretching Canvas
Directions for stretching canvases are usually supplied with the canvas rolls. One special tool you will need is canvas pliers. I also prefer using a staple gun rather than tacks. I like to attach braces to the stretcher strips to keep the canvas square, but I remove them once the canvas is stretched.

Cotton
This canvas is the least expensive. It usually has a fairly even weave but is more likely to weaken and warp over time. It is perfectly fine, however, for beginners.

Linen
The standard for centuries, linen is a long, strong fiber which resists stretching. You must look out, however, that the weave is not too uneven or bumpy. It can also be very expensive.

Synthetic
New canvases have been introduced in the last twenty years, such as Fredrix brand Red Lion, which are stronger than natural fibers and have an extremely even weave.

primed cotton duck canvas. This is the same kind of canvas that is used for most standard-size, prestretched canvases, and is convenient if you don't want to stretch your own canvas.

Canvas is not the only surface to which a ground can be applied. Artists frequently paint on panels made of wood, Masonite or illustration board. I recommend illustration board for making smaller studies, so I'll talk more about how to make panels in the next chapter in which I make a landscape sketching demonstration.

PALETTES

There are different options that can be taken with palettes, but the traditional wooden oval palette with a thumb hole is what I prefer to use. I paint while standing, and I like to walk back and forth in front of the picture. With a hand-held palette, I can mix my paints wherever I happen to be standing. And I also find it easier to judge the color I'm mixing against the warm brown background of the wood.

Arranging Colors
I like to arrange my palette in the same order every time. White is in the middle. To the right, the yellows are arranged in succession to blue. To the left, the reds are arranged in succession to umber and black. This way I get used to reaching to the same place for all my colors.

Light Yellow

Lemon Yellow or Cadmium Yellow Light

Medium Yellow

Naples Yellow or Cadmium Yellow Medium

Dark Yellow

Yellow Ochre or Transparent Gold Ochre

Brilliant Red

Cadmium Red, Cadmium Red Light or
Vermilion

Medium Red

Indian Red

Dark Red

Alizarin Crimson or Rose Madder

Red-Brown

Burnt Umber or Burnt Sienna

Green-Brown

Raw Umber

Black

Ivory Black or Lamp Black

Violet-Blue

Ultramarine Blue or Cobalt Blue

Green-Blue

Phthalo Blue or Prussian Blue

Palette Colors

A fairly standard palette for oil painting consists of about ten to twelve colors, one for each of the categories listed above. The first colors listed are my own preferences, and these are the colors I've used for the samples shown. Options for white (which is not shown) are titanium white, flake white or zinc white. I've added titanium white to each sample to show how colors appear when lightened. With these few colors you can achieve about 98 percent of the colors seen in nature.

PAINT THINNER

For a paint thinner you have the option of using pure gum turpentine or mineral spirits (a petroleum distillate). Turpentine is the traditional option, but it tends to be more expensive and some people dislike the odor.

Thinner is used to clean oil paint out of brushes and off of the palette. Thinner is also used to thin paint at the early stages of a painting, when the paint is initially applied to the canvas. The thinner essentially dilutes the vehicle (mostly oil) that is already in the paint, thus decreasing the oil-to-pigment ratio. When the paint dries it will have a less glossy surface.

If you want to apply another layer of paint over the first layer, it is best that the first layer have a surface like this. Oil paint will only adhere to the surface beneath it if that surface is permeable and less oily than the paint you are applying. Traditionally artists have used the maxim "fat over lean," meaning oily paint should only be applied over less oily paint.

MEDIUMS

The oil that you mix into your paint is called the medium. There are several options. Linseed oil is the most common medium and is the oil most often used as a vehicle for manufactured oil paints. It is fairly fast-drying, but it has a tendency to yellow over time. You don't want to have too much linseed oil mixed with the whitest areas of a painting because that is where the yellowing will show up the most.

Stand oil is polymerized linseed oil, which means that it has been heated without oxygen. This makes it less yellowing and faster drying. It is also thicker and a little more expensive than linseed oil.

Poppyseed oil has the advantage of being virtually free of yellowing, but it is much slower to dry. Because of its nonyellowing qualities, poppyseed oil is often used as a vehicle in the white paints of the more expensive brands.

Alkyd mediums are synthetic, petroleum-based mediums. They have not been around for a long time but they are known for their nonyellowing and fast-drying characteristics. One of the drawbacks is that they tend to dry too fast and become gluey.

A lot of manufacturers have brand name mediums, such as Winsor & Newton's "Winton" and Liquitex's "All-Purpose." These mediums are usually nothing more than mixtures of the various mediums I have already mentioned. Most artists mix combinations of their own depending on what they become comfortable with and consider important. My own mixture is about two parts stand oil, two parts poppyseed oil and one part paint thinner.

Using Paint Thinners

Paint thinner and oil mediums can be mixed into your colors to make them more liquid. I usually mix with paint thinner alone when applying colors initially to the canvas. Oil mediums I use very sparingly, and only when I'm working over a layer of paint that has dried.

BRUSHES

I paint almost entirely using bristle brushes. Bristle brushes are usually made of hog's hair, and the best bristles come from wild hogs found in the Chungking province of China. Hog's hair bristles have the stiffness and paint-retaining quality that make them the accepted standard for oil painting.

Sable brushes can also be used for oils. Sable hairs are very soft and fine. They do not retain much paint and they put the paint on the canvas in a very thin, smooth layer. They are usually used for highly refined modeling during the finishing stages of a painting.

Oil brushes come in essentially three shapes: flats, rounds and filberts. A brushstroke made with a round (the left brushstroke of the three parallel brushstrokes illustrated at top) tends to be pointed at the beginning and less strongly defined at the sides. Rounds lack "control" but they retain the most paint and allow for the longest uninterrupted brushstrokes.

Flats, like their name implies, are flat, thin brushes with the ends cut off in a straight line. Shorter, stubbier flats are called brights. A brushstroke made with a flat (the brushstroke on the right in the illustration at top) will look squared off at the beginning and strongly defined at the sides. The stroke is shorter because flats hold less paint. They have lots of control, but they can also look overly mechanical.

Filberts are basically flats with rounded ends. A brushstroke made with a filbert (the brushstroke in the middle) will have a slightly rounded beginning, but will retain much the same control as a flat. Filberts allow for a very painterly brushstroke, and they are very popular with oil painters.

Brushstrokes
These three brushstrokes were made by large bristle brushes. Round brushes (left) hold the most paint, make good long brushstrokes, but have loose edges. Filbert brushes (middle) don't retain as much paint as a round, but they give the artist more control. Flats (right) allow for the most precision and control, but brushstrokes tend to look choppy and mechanical.

Applying the Paint
I like to initially apply my paint quickly using the side of my brush in a sweeping motion. The first swatch shows what this looks like when I first start to paint and combine my colors with ample paint thinner, to the consistency of water. The second swatch shows what it looks like as I progress a little further. I add less thinner so that the paint has the consistency of cream.

Selecting a Brush
The brushes I prefer to use are made up primarily of bristle filberts, ranging from size 2 to 14. Also included among the collection are some large bristle rounds, smaller sable flats and bristle fans. The sables are used only when doing final detail work in my more highly finished paintings. A fan can be useful in smoothing over particularly rough brushwork, but I use it only very sparingly.

MIXING COLORS

Whatever oil colors you choose to use, it is good to get used to the same colors. It is also good to get used to reaching for them in the same place on the palette. I always lay out my colors in the same order, with white in the middle, so that I know where to reach for them.

When mixing paints on your palette, it is best to achieve whatever note you are striving for by mixing as few different colors as possible. You should first try to make the note by mixing only two different colors plus white. If that doesn't work, you can try introducing a third color. But if you add more than three colors you run the risk of making mud. Always clean your brush between mixing different colors. If different color notes that you have mixed are allowed to pollute one another, they will all begin to look muddy.

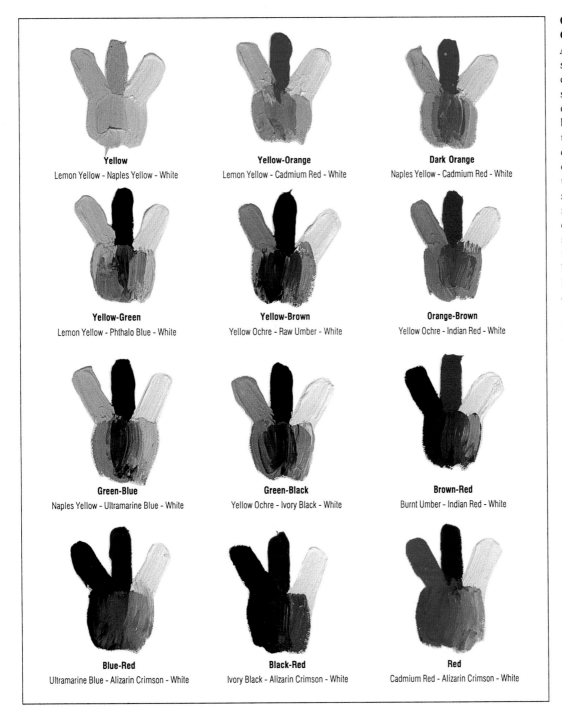

Yellow
Lemon Yellow - Naples Yellow - White

Yellow-Orange
Lemon Yellow - Cadmium Red - White

Dark Orange
Naples Yellow - Cadmium Red - White

Yellow-Green
Lemon Yellow - Phthalo Blue - White

Yellow-Brown
Yellow Ochre - Raw Umber - White

Orange-Brown
Yellow Ochre - Indian Red - White

Green-Blue
Naples Yellow - Ultramarine Blue - White

Green-Black
Yellow Ochre - Ivory Black - White

Brown-Red
Burnt Umber - Indian Red - White

Blue-Red
Ultramarine Blue - Alizarin Crimson - White

Black-Red
Ivory Black - Alizarin Crimson - White

Red
Cadmium Red - Alizarin Crimson - White

Common Color Combinations
Arranged here are some common combinations showing the range of colors that can be achieved with the standard palette. Whatever color you are trying to achieve, you should first try to make it using only one or two combinations, such as these. Clean your brushes thoroughly between mixing combinations and try to avoid reaching for the cadmiums to enrich muddy colors.

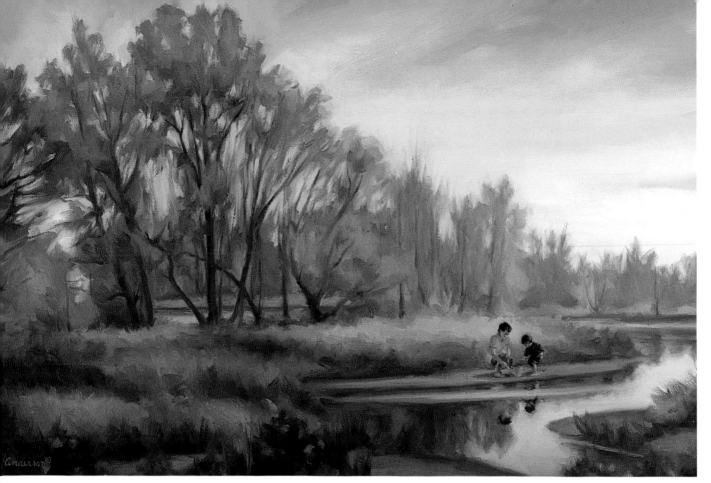

This is an example of a landscape painted using the layered method. This technique allows me to see the picture as a unit as I bring more detail into it, so I am able to bring just the right amount of detail to suggest the foliage without overdoing it.

October, 12" × 18"

THE RIGHT METHOD

You have essentially three approaches to choose from when working with oils: the layered method, the direct or *alla prima* method, and the monochromatic underpainting method. These are only broad categories, with many variations possible within each—as many variations as there are artists.

The monochrome underpainting method is one of the oldest approaches to oil painting and although there are many different variations, the principle is the same: You initially render your whole painting in a single color. After this underpainting has dried, color is introduced in subsequent layers. Rubens, for instance, used a reddish-brown pigment as his underpainting. He allowed this to show through the subsequent layers, especially in the shadows, but all the colors he used had to harmonize with this underpainting. This approach tends to be used by artists who, like Rubens, paint imaginative scenes using color "formulas."

The alla prima and layered methods are more appropriate for artists who want to render the colors they are actually seeing. My own preference is for the alla prima method. With this method the blank canvas is covered and finished with a single layer of paint. If the entire picture isn't finished in one session, whatever portion of the canvas is covered with wet paint is finished while the paint is still wet. This method will be introduced in the next chapter which will include a landscape sketching demonstration.

The basic principles of oil painting, however, are best learned by using the layered method. In discussing paint thinner and medium I already alluded to the idea that oil paint can be applied in a series of layers, so long as each successive layer has more oil in it than the layer beneath it. What such a procedure allows you to do is to see how your painting differs from nature and improve it with each successive layer. I call this a "searching" method of painting. It allows you to search for just the right shape, value and hue until you get what you want.

DEMONSTRATION

Painting a Still Life Using the Layered Method

GETTING STARTED

For a first still life I suggest that you select simple objects like the ones I chose for the demonstration. The four apples, earthen jug and enamel cup provide a sufficient variety of color and texture to make an interesting picture, without being overly complicated.

Using the sight-size method, I placed my easel directly beside the still life and chose a viewing point from which all of my observations were made. My first step in the process was to make a drawing the exact size that I intended to paint it. This allowed me to work out subtleties in the composition and to determine the exact proportions of the painting before I stretched my canvas. It's also helpful to have the basic drawing already established as you begin to paint, so that you can concentrate on color and value. I used charcoal and chalk on toned paper for the sketch, and as you can see, I worked broadly and didn't bring it to a high degree of finish.

When I established the outside dimensions of the picture, I made the height and width measure to exact inches (stretcher strips for canvas come only in full-inch sizes). You can easily experiment with different outside contours by cutting strips of paper and blocking off the picture on one or more sides.

After the drawing was finished, I sprayed it thoroughly with a charcoal fixative. When it dried, I placed a piece of tracing paper over the drawing and outlined the contours in the still life onto the paper. I then traced the contour drawing onto the canvas using graphite paper.

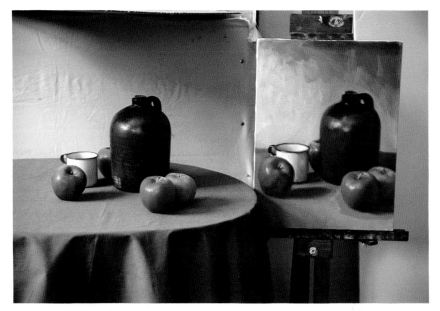

Set Up and Lighting
The still life is illuminated by a high north-facing window so that the light is steady and is never disturbed by direct light from the sun. The easel is placed next to the still life, and all of my observations are made from a point about six feet in front of it so that I can easily compare the two.

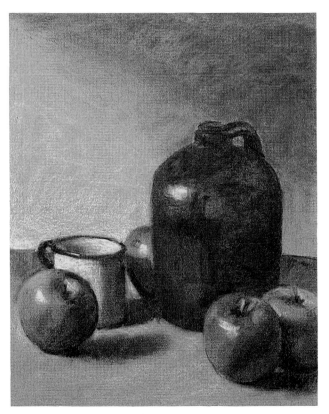

Preliminary Drawing
I began the demonstration by making a drawing on toned paper with charcoal and chalk. I recommend that beginners do this to work out problems with the composition. To transfer the drawing, place tracing paper over it, outline the contours, then retrace them on the canvas using graphite paper.

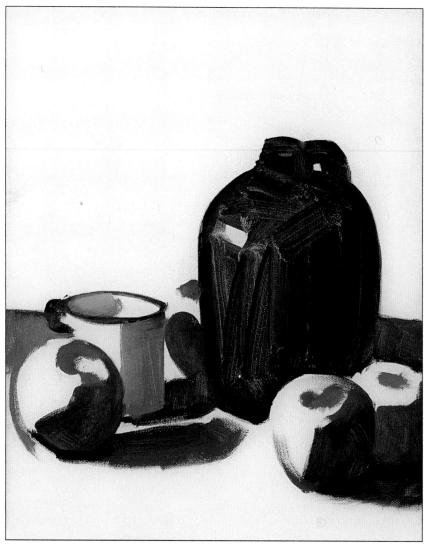

Step One—Apply Dark Color Notes
When I initially apply paint to the canvas I mix the colors generously with paint thinner. The first color notes I applied were the darkest ones, since it's impossible to judge what the lighter ones should be against the white canvas.

THE LAY-IN

The first layer of paint applied to the blank canvas is called the lay-in. With this layer I add lots of paint thinner to my colors as I mix them, thinning them to the consistency of cream.

If a large area of canvas needs to be covered quickly, but not very thoroughly, I often use the side of the brush, stroking it back and forth in an arc. The first stroke (at the lower left) shows what such a brush-stroke looks like when the paint is highly thinned with paint thinner. It was with this sort of stroke that I painted the initial lay-in.

The first color notes I mixed are the darkest ones. It's impossible to judge the value of the lighter notes when you first apply them to the white canvas—they always look too dark. It's much easier to judge whether the dark notes are fairly correct. Once those are massed in, you can easily determine the lighter notes against the darker ones. So I work over the entire canvas, first putting down the darkest notes, then the middle values, and finally the lightest value in the picture.

As the entire canvas gets covered, I mix the paint across the contours of objects so that they are blurred. This is important for three reasons: One, this keeps you from painting every detail of the picture in perfect focus, which will make your painting appear too busy and hard-edged. Instead, you want to strive to achieve the broad visual impression—the "big look"—from the very beginning. I like to start by painting everything as it appears when my eye is completely out of focus. As I proceed I bring the picture increasingly into focus. I may decide to bring a great deal of detail and finish to certain areas, but I do this only at the

very end, when I'm working on the final layer.

Two, the drawing that is transferred to the canvas is not perfect. As I push the painting to greater finish, the shapes will need to be drawn with greater accuracy. Losing the contours helps me to ignore the old drawing and reexamine the shapes of the contours.

Three, blurring edges prevents the paint from building up in ridges along the contours. If you paint a hard contour by following the line with your brush, the little ridge of paint it creates will interfere later if you want to soften or alter the contour.

In painting the lay-in I don't have to worry that the drawing or color notes are not perfect. The purpose of the lay-in is to get the entire canvas covered. Then, when I apply the next layer, it will be much easier to get the exact color and modeling without bare, white canvas breaking through. For this to be effective, I allow the lay-in to dry thoroughly (approximately two days) before applying the next layer.

THE SECOND LAYER

The second layer of paint is applied much thicker than the lay-in. In fact, I sometimes use the paint as it comes directly from the tube, especially when I want the paint to have texture. However, I usually like to thin the paint slightly with the painting medium I keep in one of the palette cups (four parts stand oil to about one part paint thinner).

My objective with the second layer is to reexamine and correct problems with the drawing, the color and the composition. I also build up the paint where I want to have texture, especially in the highlights. This helps because the light will then catch those areas and cre-

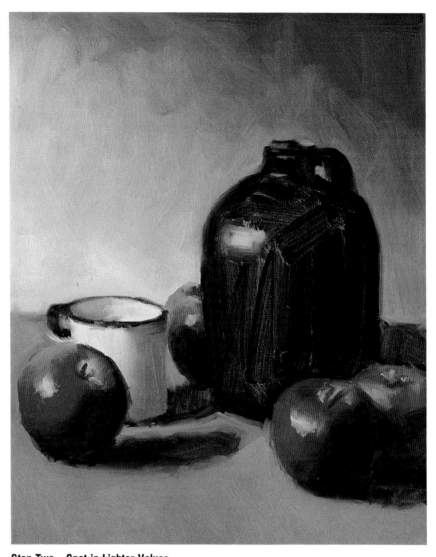

Step Two—Spot in Lighter Values
When the darkest values were established, I spotted in the lighter values. To keep everything at the same level of completion, I worked over the entire canvas. I also worked across the contours to blur them.

ate a slight shimmer. While this can sometimes be effective in the light areas, it tends to break up the darker notes, so for those notes I usually add medium to the paint to make it thinner.

With the first layer my objective was to get the entire canvas covered, which I did in a single session of a couple of hours. With the second layer, however, there is no need to get the entire surface covered. In-

stead, I take isolated sections of the picture and concentrate on bringing as much finish to those areas as I can.

In this instance, I used one session to concentrate on the apples in the foreground. I completely covered the apples, and the area that surrounded the apples, with paint. After everything was covered, I touched in more subtle color notes and then carefully modeled the form

and searched out the contours.

A good procedure to follow is to finish foreground objects first and then move backwards in the painting, finishing the background last. After all the separate objects in the still life have been completed, they'll be surrounded by little "halos" of finished background. So the overall background should be put in at the very end and carefully merged with the parts of the background already painted.

It is when you're merging wet paint with paint that's already dried that you'll find retouch varnish to be very useful. Sometimes after an area of an oil painting dries the color changes and it looks chalky and "sunken in." This is because the oil has been absorbed into the layer beneath it. Oil can be put back into that area, and its original color and sheen restored, by applying retouch varnish. Oil paint can be applied over the top of retouch varnish after it has thoroughly dried.

Although I finished my demonstration with two layers, that doesn't need to be the case. Beginning artists often use three or more complete layers before they are able to zero in on just the right look. Even when you come to what you feel is the final layer, you may not necessarily succeed with every part of the picture. After that final layer has been applied, you can still alter a shape, soften a contour, or add color notes. Just remember to work within the "fat over lean" dictum. It is very easy for the surface of your picture to quickly become too oily, and once that happens, the paint will bead up and will not adhere to the layer beneath.

SEEING THE WHOLE

One of the great advantages of the layered method is that from the very beginning you see the picture as a unit. As you add more layers, and bring more finish to the picture, you can see whether the shapes and

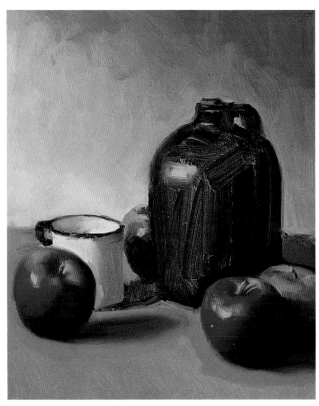

Step Three—Begin Second Layer
After the first layer was completed, I allowed it to completely dry for two days. Adding just a little oil medium to my colors, I began the second layer by concentrating solely on the foreground apples and the area that surrounded them.

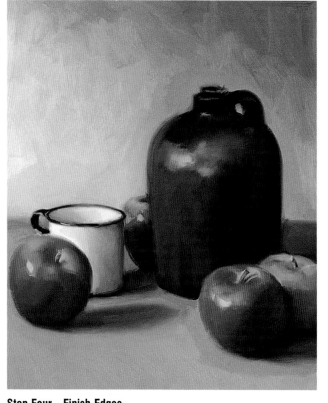

Step Four—Finish Edges
I continue to work on the second layer, until all the objects in the still life are finished with a little "halo" of background surrounding them. This allows me to finish the edges around the objects as I paint them without having to finish the entire background.

colors are consistent with what is already on the canvas.

This keeps the artist from falling into a number of typical pitfalls. One is overmodeling—that is, overly exaggerating variations in the form and detail. Another is inconsistencies in the shapes—getting one particular shape perfect, but not relating it properly to all the others.

For instance, it would have been very easy for me to have become overly involved in working out the subtle shapes of the handle and the ellipse on the cup, forgetting to see how it related to the picture as a whole. By quickly getting the broad masses and big shapes, without worrying about the detail, I've established the proper size of these details in relation to everything else. As I put more details down in the second layer, I am more likely to make them fit properly with everything else in the picture.

While my demonstration was painted somewhat loosely, in the style I prefer, the layered method allows you to bring enormous detail and finish to a picture, probably more so than any other method.

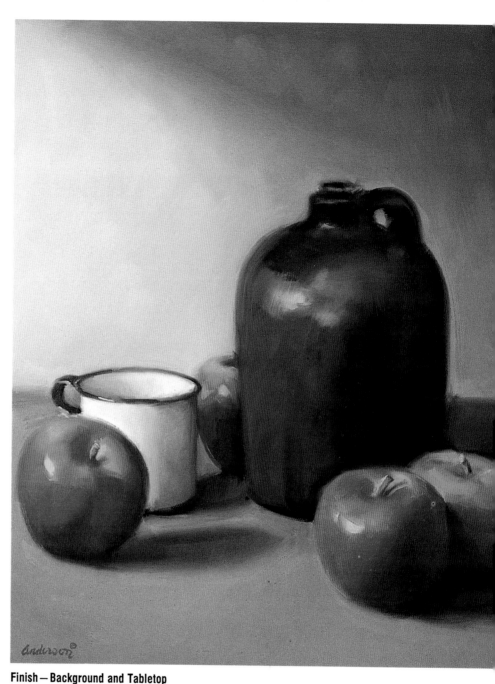

Finish—Background and Tabletop
I finish the 18″ × 14″ still life by completing the background and tabletop. I work the background up to the edge of each object allowing it to dissolve away just before reaching that edge. This way I avoid the seams cutting through the background area itself.

LEARNING TO SEE

At the beginning of this chapter I said that the basic technical requirements of oil painting are simple, but that is not to say that oil painting itself is simple. It has been said that the process of learning how to paint is the process of learning how to see. If you can properly identify in your mind the actual shapes, colors and values of whatever you happen to be looking at, you can paint it.

Artists who become obsessed with oil painting techniques sometimes lose sight of this. Nonetheless, it is only by understanding the basic technical requirements of oil painting that you can be free to pursue those visual discoveries.

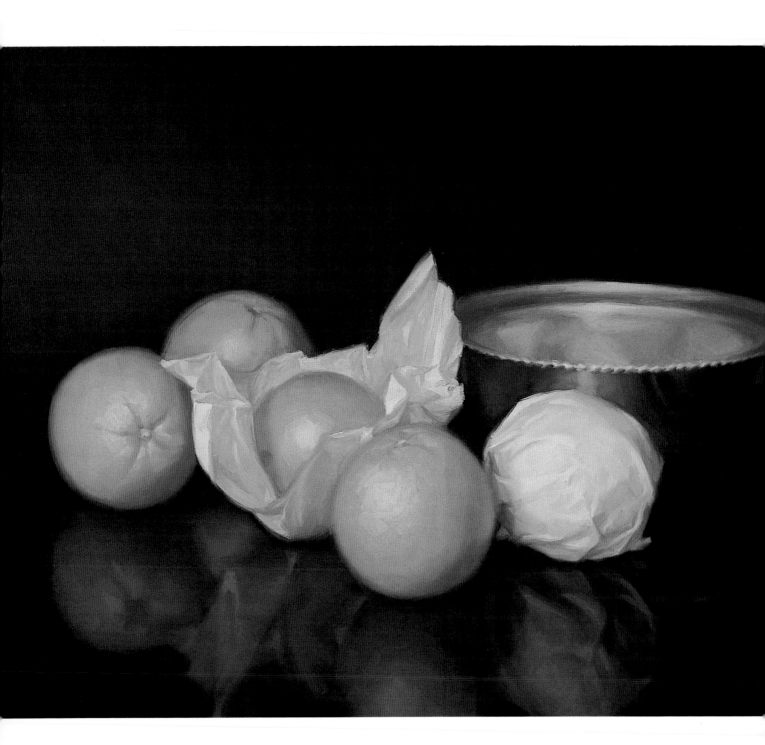

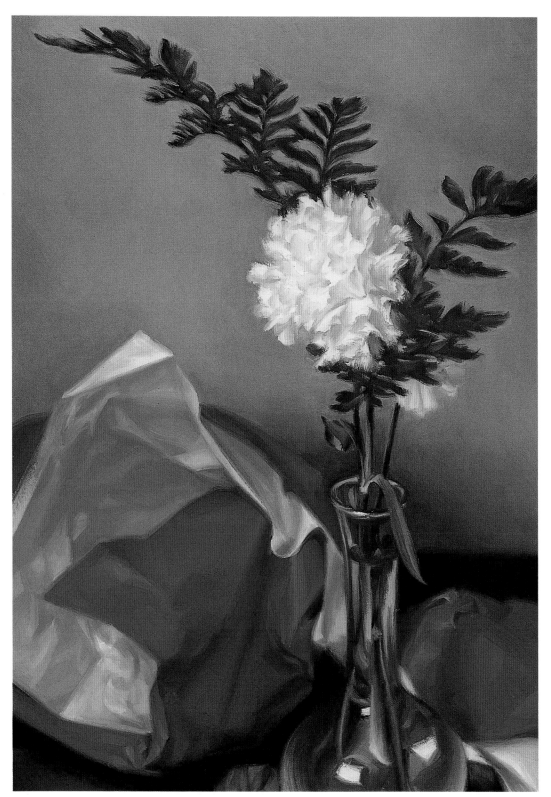

(Left.) I added a cadmium orange to my palette to achieve the rich orange color I needed here. Even this orange became too dull, however, when added to white for the highlights. I compensated by making the orange note surrounding the highlights a richer orange than I saw, thus fooling the eye into thinking that this rich hue extended into the highlight.

Still Life With Oranges, 16″ × 20″

(Above.) This is an example in which the highlights, especially in the flower head, were painted with thicker paint than the other values. The thick paint picks up the light and creates a slight shimmer adding to the three-dimensionality of the picture.

Yellow Carnations in a Bud Vase, 19″ × 13″

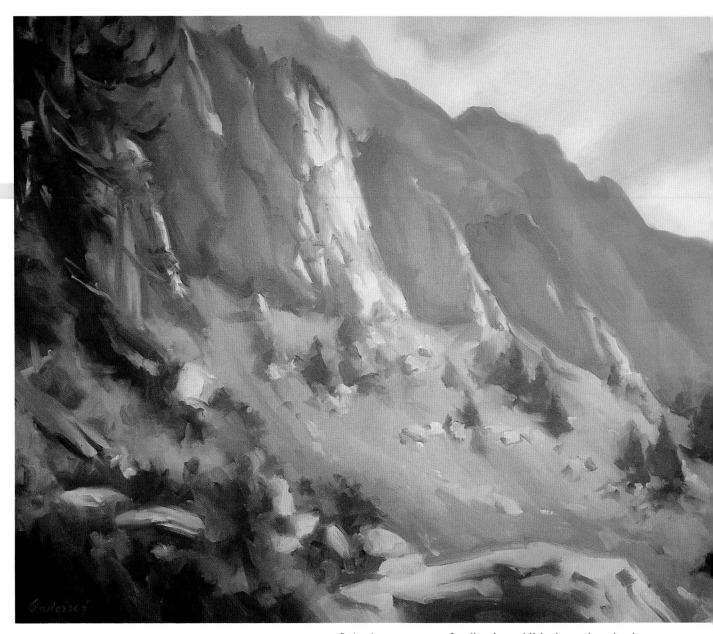

In landscapes a sense of realism is established more by color than by anything else. In a scene such as this, there is far too much detail to even come close to actually painting it. Ignoring detail altogether, I try to capture the subtle differences in color and value created by the atmosphere that comes between me and the various planes in the scene.

Alpine Cliffs, 24″ × 30″

Learning to See Color

I had been attending art school for several years, and had a considerable amount of studio painting experience, before I first decided to try my hand seriously at *plein air* (or out-of-door) landscape painting. I prepared myself by reading some books on the subject and was surprised at the colors some of these artists recommended that I use. I was surprised at the absence of earth colors, like yellow ochres and brown umbers, on these palettes, and they all seemed to warn against the use of black. Instead, the colors most often recommended were bright colors like cadmium reds and lemon yellows, and strange, almost fluorescent colors like dioxazine purple and phthalocyanine blue. These seemed like colors appropriate for decorating birthday cakes, not the sort of colors you see in nature.

It was only after I gained some experience painting out-of-doors that the logic of these palettes began to sink in. The colors that you see are so rich that there is never an occasion when you will need a black, not even on cloudy days. And even with the colors in your landscape that you would normally think of as brownish or "earthy," there are so many reds, yellows and purples, that if you don't mix the note using those kinds of colors, the note you make will invariably look too muddy and dull.

A Color Experiment

The qualitative difference in color hue between what you see indoors and what you see out-of-doors is so enormous it is difficult to comprehend. But there is one simple experiment that I suggest you try. If you are sitting inside, and it is daylight outside, all you need to do is look out a window through a small peephole, either cut out of a piece of cardboard or made by looking through your curled finger. Move your peephole so that you see part of the window frame as well as some of the landscape beyond it. Notice what the color and value of the window frame are compared to the color and value of the darkest shadows in the landscape. Even if the window frame is painted white, it will probably look black compared to those shadow notes outside. And those shadow notes may very well look like a bright pastel purple in comparison to the window frame.

This gives you some idea of the great differences between indoor and outdoor color. Now the experiment is slightly flawed in one respect. When you actually step outside, your pupil will adjust for the increase in light. When you look at the same scene while outside, the shadows will indeed appear darker. But they will still have those rich colors that you saw while comparing them to the window frame.

Capturing Outdoor Color

It really wasn't until the nineteenth century that artists began to comprehend and paint true outdoor color. Until that time true outdoor color was considered to be unpaintable and, oddly enough, too ugly for anyone to bother painting. Artists relied instead on color formulas, usually with umber and sienna underpaintings. This would bring a sort of warm reddish-brown unity to all the shadows, while the areas in sunlight would be painted with cool notes. This is the opposite of what we really see happening in nature. In actuality it is the shadow areas that are cool in comparison to the areas hit by direct sunlight, which are warm. But even an artist like Rembrandt, who was a naturalist painter when working in the studio, would revert to brownish color formulas when painting landscapes.

When the early Impressionists first displayed their paintings, people were confused and didn't know what to make of the bright dabs of color used to paint everything from blue sky to tree trunks. But as the volume of these pictures increased, and they were seen in comparison to the older style landscapes, it became clear that this is what nature really looked like—that to walk from a room filled with Baroque landscapes into a room filled with Impressionist landscapes was to walk from a sort of tedious gloom into the bright light of day.

Learning to capture the bright light of day isn't easy, but it can be an enormously rewarding exercise, even if you aren't interested in pursuing landscape painting. Landscape sketching is an excellent way to learn to see and capture color for the same reason drawing the human form is the best way to learn how to capture shapes—because when you make mistakes they are so glaringly obvious. It forces you to paint with the richest colors, and that, in turn, will help you to see color in what-

Gridded Viewfinders and Peephole
The "peephole" is a small piece of cardboard covered with black velvet with two small holes cut in it about ten inches apart. By holding it in front of your face you can isolate whatever color you want to paint and see what it looks like compared to black. You can also position the peephole so that you see the color you want to paint through one hole, and the color you've actually painted through the other, and compare them. The gridded viewfinders were made using elastic thread so that the threads would remain taut. I use the boundaries of the viewfinder to see how the scene before me composes as a picture, while the grid helps me to see how the various shapes in the scene relate to one another.

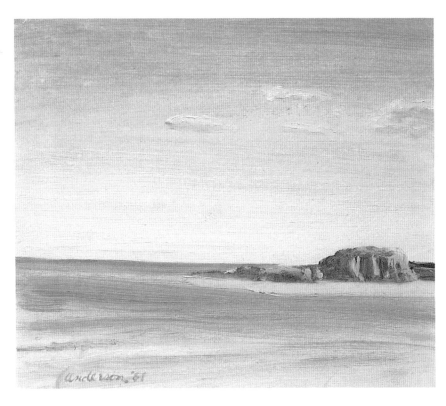

By painting quickly and very small you can capture colors that are very fleeting. This tiny sketch was probably painted in 15 minutes, about as long as you can paint during the quickly changing light at sunrise.

Sunrise, Lake Superior, 5" × 5"

ever you might choose to paint.

It also teaches you to capture the broad visual impression. There is entirely too much detail in landscapes for them to be rendered precisely. Working quickly on a small scale forces you to ignore detail altogether.

DIVIDING THE DAY

The goal with landscape sketching is to capture your immediate impression of a scene during a particular time of day. So when painting outdoors, it's often convenient to divide the day into parts. On a clear day, the light holds steady the longest during the mid-morning and the mid-afternoon—from two to three hours. The better light comes in the early morning and the late afternoon: The shadows are longer and the light is warmer, especially in the late afternoon when there is more dust in the atmosphere. These periods, however, may last less than an hour.

Near sunrise and sunset the light changes very quickly. During this time, only very quick studies can be made—fifteen minutes or less. The sunset itself, and the colorful cloud effects, are almost impossible to paint while observed. For these fast-changing scenes, artists often learn to memorize the color notes in order to paint them later. For this purpose, some artists make quick pencil outlines of the forms they see and then add written color notations.

I like to stand while painting in order to easily step back from my easel. It's best to make your observations from a slight distance so you can see whether the painting is unified.

I always set up my easel so that the painting is in shadow. If you don't use an umbrella you can turn your easel so the sun doesn't hit the front of your picture. However, in doing so you may be facing a different direction than the scene you are painting. Using a tall umbrella will eliminate this problem. You can use it to cast a shadow on your painting, as well as on your palette and yourself. If it's hot or raining outside, an umbrella is an imperative.

When I'm searching for a scene to paint, I carry around a viewfinder. This is just a piece of cardboard with about a 5 × 7-inch rectangular hole cut out of it. I hold it up in front of me to frame a scene that might be interesting. After I find the right scene, I use the viewfinder to help me block out the initial drawing. I note, for instance, where the horizon line hits the side of my viewfinder. I then mark it on my panel using a light wash—usually a blue or purple note mixed generously with paint thinner. In this way, the basic shapes are very quickly and broadly blocked out.

MASSING IN

Since the object of the sketch is to capture the immediate impression of a scene during a particular time of day, you must work quickly. Ideally, the picture should be painted with a single coat of paint, or alla prima.

I take my eye out of focus so that I can see more easily the broad masses of color. Adding just a little paint thinner to my colors, I begin by massing in the darkest notes. I then mass in the middle values and proceed up the scale, leaving the lightest values for last.

Other artists that I work with prefer to start with middle values, and then compare the lighter and darker values to that. However, you should avoid starting with the lightest values, since it's impossible to judge what they should be until some darker values are established with which to compare them.

With the lighter values, I use less thinner or no thinner at all. If the paint is thicker, the brushwork will have more texture. The light hitting this texture will create a slight shimmer, which is good in the lightest areas but undesirable in darker ones.

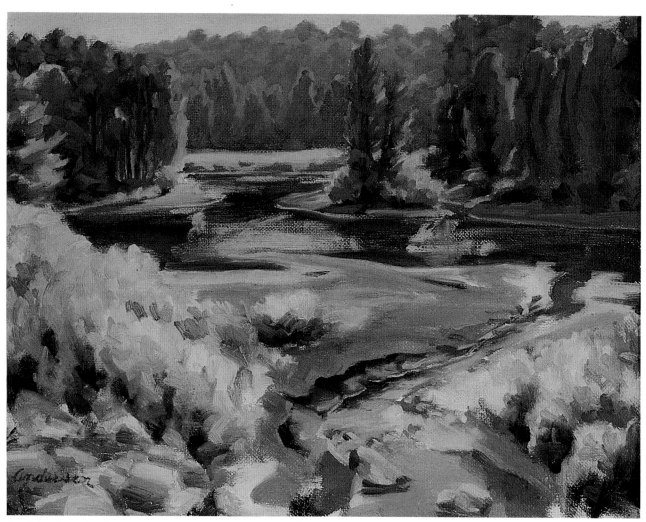

Looking Into the Sun
I especially like the light of the late afternoon with its longer shadows and richer light. In painting this 11 × 14-inch panel, I actually looked toward the sun as it was getting low in the sky, creating rich blues in the shadows and warm halos of light around the trees.

Sangatuck River, 11″ × 14″

MIXING COLORS

Whatever I'm painting, I always use the biggest brush I can get away with. This forces me to put the paint down in bolder, more unified strokes. I paint sketches entirely with bristle filberts.

Larger brushes also force me to use more paint. When I first started painting landscapes, I was far too sparing in the amount of paint I used, which made my paintings look overworked and non-unified. I think I was afraid of wasting paint. Since using a fully-loaded brush can make such a difference in the quality of your work, the fear of wasting paint is an attitude that simply must be overcome.

Whatever color note I am striving for, I try to make it by mixing the fewest different colors possible. Don't mix a color by simply adding paint to the last color note mixed. If you do, you will soon have a palette full of muddy grays. I clean my palette frequently so that there is always a clean spot to mix my colors.

I don't have any green paints on my palette, preferring to mix them from the blues and yellows. A landscape of green summer foliage can easily get monotonous. By mixing my own colors, I'm more likely to search for the exact hue of green, which I would be less likely to do if I had a ready-made one on hand.

Phthalo blue is an extremely intense, greenish-blue pigment, often used in dyes. I mix it primarily with the yellows to achieve rich yellow-green colors. I also use it to capture the intense pale blue sometimes seen in the lower part of the sky where it meets the horizon. You don't need to put a lot of this color on your palette. It's extremely intense and should be used sparingly.

I use ultramarine blue more than phthalo blue in the upper part of the sky and in shadows. It will achieve bluer, less intense greens, too.

MAKING PANELS FOR SKETCHES

If you're just learning to paint landscapes, you should paint on disposable panels. If the colors start to get muddy or you find yourself trying to save a picture by fussing over the detail, you should toss the thing aside and start over. You'll learn the most by starting pictures and throwing them away.

Sketches are usually done on gessoed panels made from illustration board or Masonite. One of the easiest ways to make panel in quantity is to take an entire sheet of acid-free rag board and paint it with premixed acrylic gesso. I use a sponge brush to minimize brushstrokes. I usually paint the board with about three coats, lightly sanding each coat after it dries. Both sides of the board should have the same number of coats to avoid warping—but only one side needs to be sanded. When I'm finished painting the board, I cut it up into numerous small panels of different sizes, from 5 × 7 to 9 × 12 inches.

Untempered, ¼-inch Masonite can also be painted with gesso and used as panels. The panels should be cut out before they're painted, the surface should be sanded somewhat for the gesso to adhere better, and the edges should be rounded off with rough sandpaper so they don't chip.

Sometimes I like to make my sketches on a canvas-textured surface. Instead of gessoing my Masonite panels, I glue a piece of canvas to them. Pre-gessoed portrait, smooth-cotton duck is what I use. It should be cut out about ¼ inch larger than the panel because it will shrink when the glue dries. After the surface of the panel has been sanded, it should be covered with wood glue.

Spread the glue so that it completely covers the surface of the panel. Then place the canvas on top of the panel and use a large book to hold the canvas flat. After the glue dries overnight, the excess canvas can be trimmed with a razor knife.

It is easy to make your own panels for landscape sketching using either illustration board or Masonite.

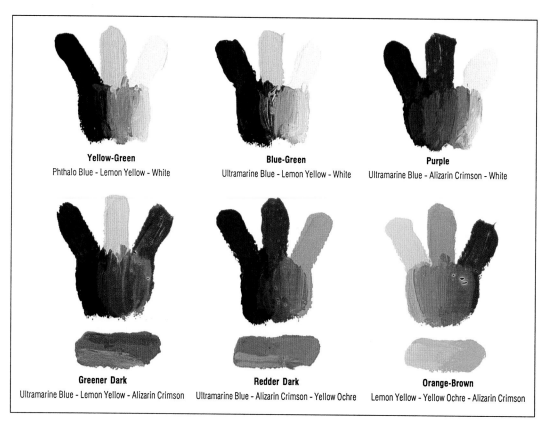

Color Mixing Chart
This shows how I mixed most of the colors I used for the following two demonstrations. The swatches under the dark-note combinations show what those colors look like with just a touch of white added.

Yellow-Green
Phthalo Blue - Lemon Yellow - White

Blue-Green
Ultramarine Blue - Lemon Yellow - White

Purple
Ultramarine Blue - Alizarin Crimson - White

Greener Dark
Ultramarine Blue - Lemon Yellow - Alizarin Crimson

Redder Dark
Ultramarine Blue - Alizarin Crimson - Yellow Ochre

Orange-Brown
Lemon Yellow - Yellow Ochre - Alizarin Crimson

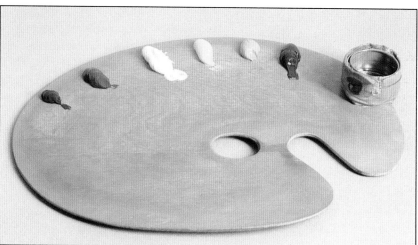

Landscape Sketching Palette
Made up of only six colors, my palette includes (from left to right) phthalo blue, alizarin crimson, titanium white, lemon yellow, yellow ochre and ultramarine blue. I keep the blues at opposite ends of the palette so that I don't confuse them. I feel that I speed up the painting process by limiting my choices of colors. I also find that I paint much richer dark notes by eliminating the darker earth colors from the palette. Even the darkest notes in nature are so rich that I am much more likely to capture that richness if I limit myself to painting with primary colors.

DEMONSTRATIONS

Capturing an Immediate Impression:
Two Landscape Sketches

Step One — Basic Shapes
I began the sketch by making a quick drawing of
the basic shapes with a pale purple mixed with a
generous amount of paint thinner. I keep the draw-
ing very light so I can easily alter it.

Step Two — Add Darker Values
Using only a little paint thinner added to my colors,
I spotted in some of the darker values. I reassess
the drawing and try to improve it each time I apply
more paint.

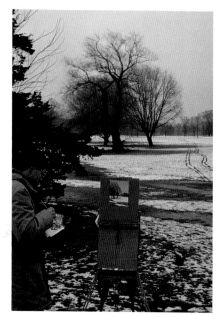

At the Scene
I like to stand while I paint so I can walk back from my picture to see whether it has unity. Since this 8 × 6-inch rag board panel was so small, I attached it to a sheet of cardboard with tacks.

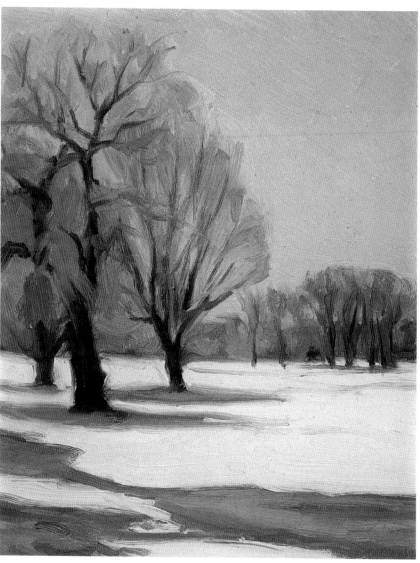

Finish—Light Values Last
I placed the lighter values last, using less and less thinner in my paint. For the snow—the lightest value—I used the paint directly from the tube to finish the sketch.

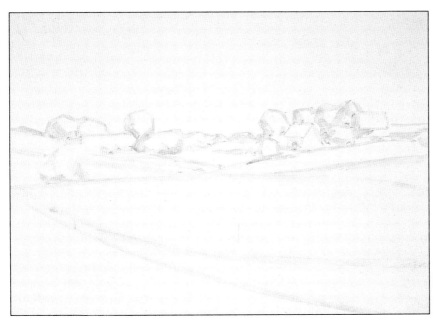

Step One—Start With Thinned Paint
A distant view, such as this farm scene, is an ideal subject for a quick sketch on an 8 × 11-inch rag board panel. My first step for this simple drawing was to sketch the basic shapes with thinned paint.

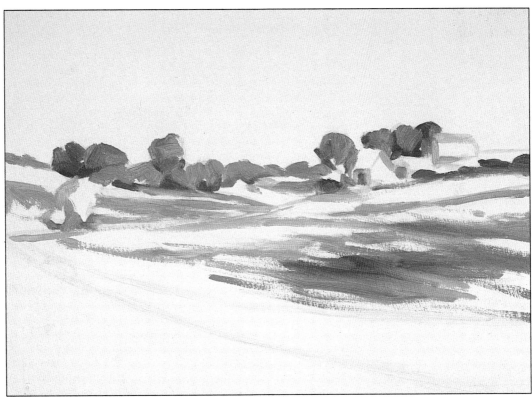

Step Two—Establish Darks
I established some of the darker values in the scene first. It's much easier to judge what the lighter values should be if I have some darker notes to compare them to.

Finish—Keep the Edges Soft

As I finished the sketch I was careful to keep the edges soft, especially where the trees are seen against the sky. To give the picture unity, it's important to look at the scene out of the corner of your eye instead of focusing on each object as you paint it.

UNEXPECTED COLOR

After a panel is covered with broad masses of paint, I work back into it and bring out the details, usually using the paint as it comes directly out of the tubes.

At this stage, I also enhance the richness and vibrancy of the color masses, making sure that I've seen and captured the unexpected color notes. To paint the true color of anything you must learn to ignore the "local" color—the color you would normally describe the object as being. For instance, you would normally describe the trunk of a tree as being brown; that is its local color. On a sunny day, however, you'll often see colors that are anything but brown. I find that I have to mix purples and reds to paint the shadow side of the trunk. And where the sun directly hits the trunk, the color is even less brown. I usually paint this with pale mixtures of cadmium yellows and reds.

I always tell my students to look for the unexpected note. If an object is blue, look for the reds and yellows in it; if it is green, look for the oranges and pinks. Every local color has within it elements of its opposite. Learning to see and paint subtle, unexpected color notes is one of the main objectives of landscape sketching.

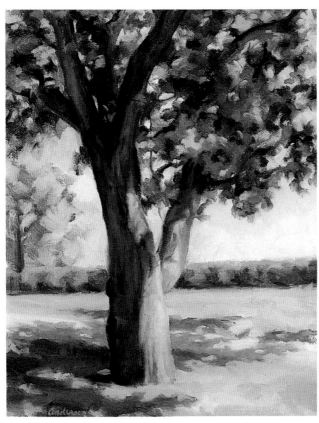

Ignore the Maze of Detail
When working on an object that's close at hand, like this tree, it's especially important to ignore the maze of detail. With this sketch, I took my eye out of focus so I could see the leaves as simple, broad masses of color. This helped me to ignore the local color and to see the leaves as a variety of yellows, oranges and blues as well as greens.

Oak on Summit Avenue, 12″ × 9″

Detail—Showing Color of Light and Shade
When a tree trunk is being hit by direct sunlight you see a whole variety of colors, almost every color in the rainbow except brown. The shadow side is primarily a purple hue. Red and orange notes caused by reflected light are seen in the middle of the shadows, while the shadows are cooler toward the edges. The light side of the trunk is primarily a pale yellow with touches of purplish-red created by the rough variations of the bark.

WARMS AND COOLS

Whatever area I am painting, I try to identify the warm notes (those that tend toward the red and orange) and the cool notes (those that tend toward blue). There will usually be lively interplay between the warm and the cool. Every shadow, no matter what it's on, will usually be "warmest" toward the middle.

This is because the shadow picks up warm notes reflected into it. I try to look for this interplay in every small area I happen to be painting, and throughout the piece as a whole. For instance, looking at a sunny-day landscape, the shadow areas should be cool in comparison to those areas where sunlight hits directly, which should be warm. When concentrating on one small area, this warm-

cool interplay may get confused so you have to look at the picture as a whole to see whether it is maintained. (As an aside, I have to mention that this is the exact opposite of what happens when painting pictures in a studio using natural light. In that case, the shadows are the warm notes and the light areas are the cool notes.)

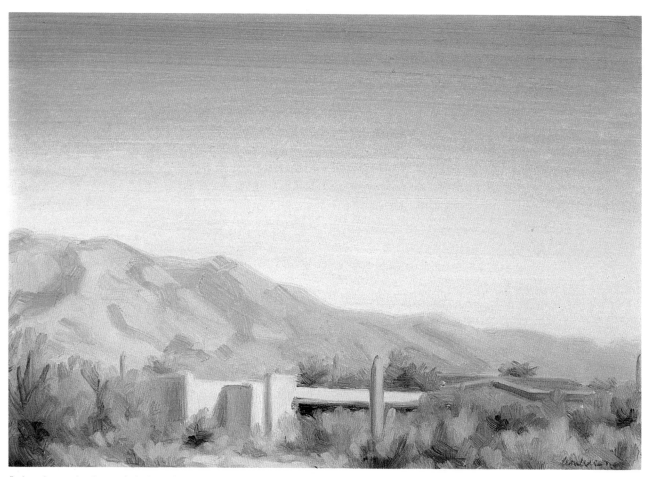

It is value and color, rather than drawing and detail, that really carry an oil sketch. In this sketch I captured the feeling of space by allowing the atmosphere and objects in it to become cooler and bluer as they receded.

Catalina Mountains, 7" × 10"

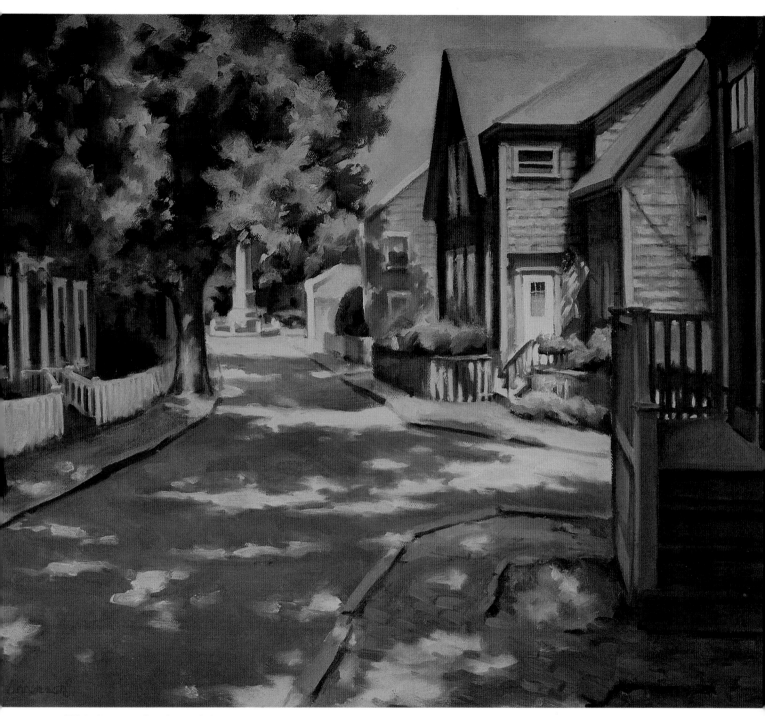

With pictures painted out-of-doors the shadows are cool (tending toward blue), while the lights are warm (tending toward red and orange). This warm/cool interplay is especially evident in this street scene because of all the shadows being cast by the trees. The shadows moved a great deal during the afternoons that I worked on this picture, but I was able to design them to best help the composition. By having the foreground mostly in shadow, the eye is led into the picture toward the center of interest — the monument at the end of the street, which is mostly in light.

Street Scene, Nantucket, 18″ × 22″

BROKEN COLOR

Finding and painting the unexpected color notes often leads to the use of a technique called "broken color." The Impressionists discovered that you can achieve the vibrating effect of light by painting spots of different colors and allowing the eye to mix them from a distance.

In painting a solid blue sky, for instance, you'll often see other very different colors as well. There are often yellow notes in the lower parts of the sky. If you were to mix the yellow and blue together on the palette, however, the green you created would be incorrect for the sky. If, instead, you put blue and yellow spots of color side by side, you could achieve the warm, vibrant hue that you actually see.

In using broken color to achieve a particular color note, it's important that the values of the different spots of color all be the same: otherwise, the picture will look spotty. If you use blue and yellow to paint the over part of the sky, both the blue and yellow notes should have the same value. In other words, if a black-and-white photograph were taken of the painting, the two different colors should be exactly the same gray.

The real test for plein-air paintings comes when they are brought inside. Colors that look rich and bright outdoors often look dull and muddy under less intense indoor light. Some Impressionist painters actually exaggerate the colors they see to compensate for this effect.

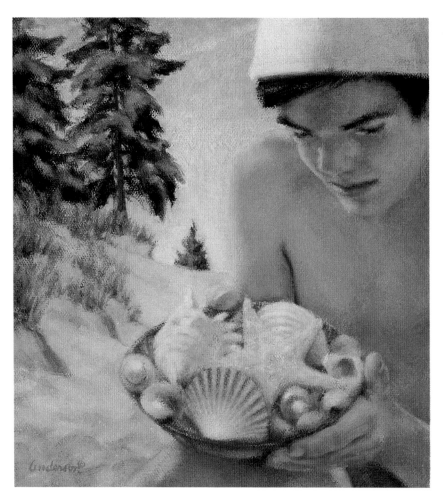

Color Study
The vibrancy of color seen in this small study (9″ × 8″) was created with broken color. With this technique, small spots of different color are used side by side, which the eye then mixes at a distance.

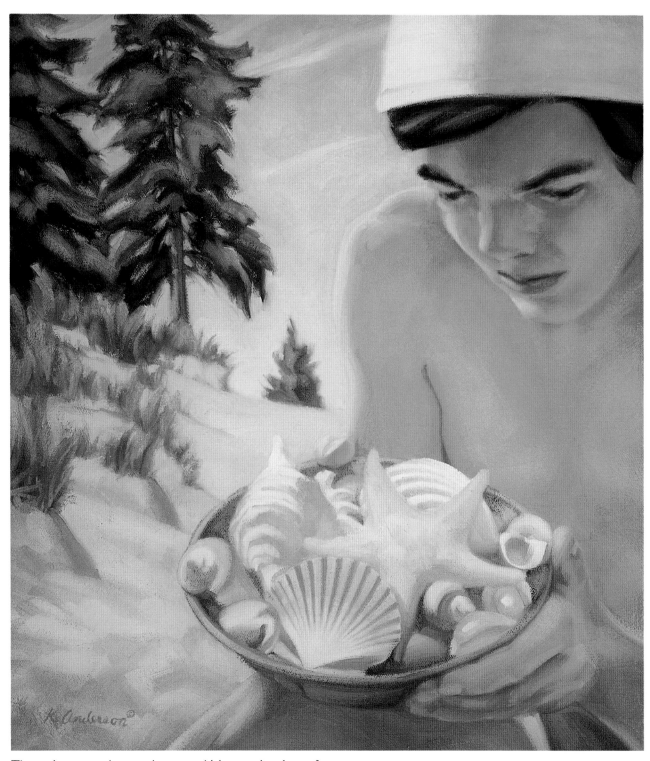

The study seen on the opposite page, which was painted out-of-doors, was used to paint this larger picture in the studio. Each picture has its own virtues. Working in the studio allows you to create larger, more carefully honed pictures. But it is almost impossible to capture the vitality of outdoor color without actually being on the spot.

Boy With Shells, 17″ × 15″

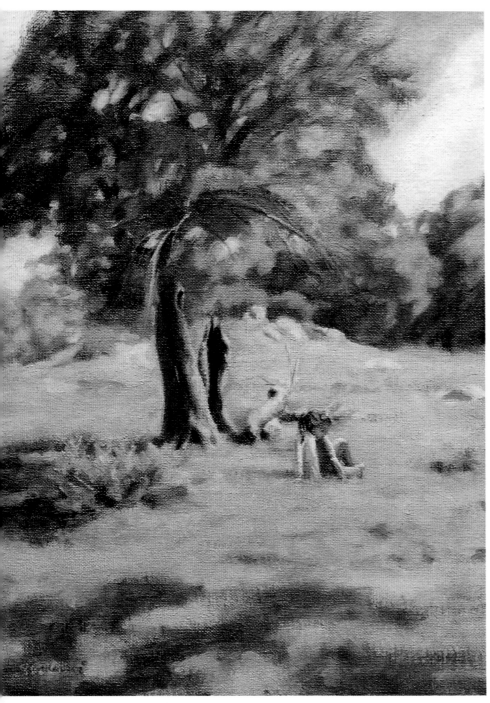

One of the most difficult things to achieve in landscapes is the full range of values that you see in nature. To show the brightness of the sunlit areas may require pushing the shadows just a little darker than you actually see them. This is one of the ways I created a sense of bright, shimmering light in this small painting.

The Apple Tree, 14″ × 11″

JUST RELAX

No matter what you're painting, it's important to have a good eye for shapes and form, but landscape sketches let you relax in this regard. A common mistake made by students is trying to make their sketches work by getting the drawing and detail just right. However, it's color and values that will carry a landscape sketch. If it isn't working out in this regard, it should be tossed aside and a new one started.

If you approach each landscape sketch as an experiment, you're much more likely to learn from it. This is the spirit in which it should be approached. Whether you enjoy working on subjects outside, in the studio, or from ideas entirely in your imagination, painting sketches can be an essential way of developing your eye for subtle colors and effects found in nature.

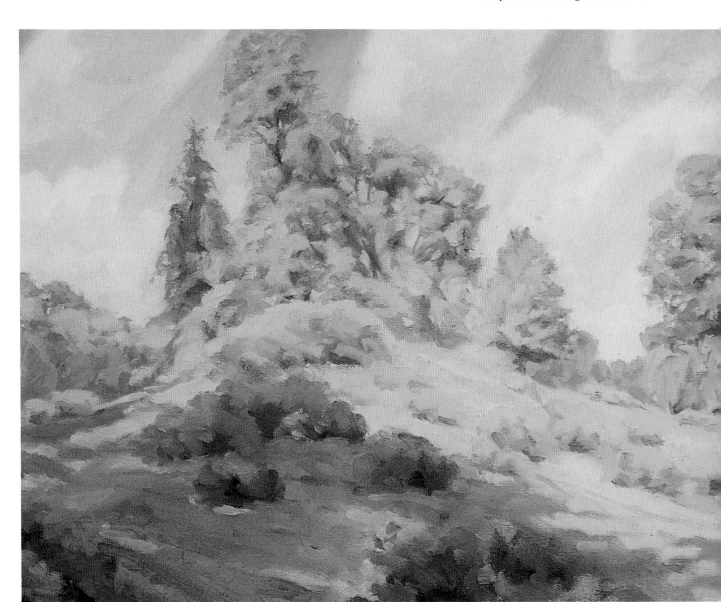

I made this painting and the one on the opposite page on the same two days, in the same pasture. I worked on this picture in the mornings, and after having a leisurely sack lunch, worked on the other picture about fifteen yards away in the afternoons.

If you want to work outside over the course of a day, it is essential to divide the day into parts like this. In summer you can get away with working on one picture for about two and a half hours in the mid-morning and on another for about two and a half hours in the mid-afternoon. As the sun gets lower in the sky, you may only be able to work on the same picture for a half hour. And sunset effects last only a few minutes.

Hilly Pasture, 12″ × 16″

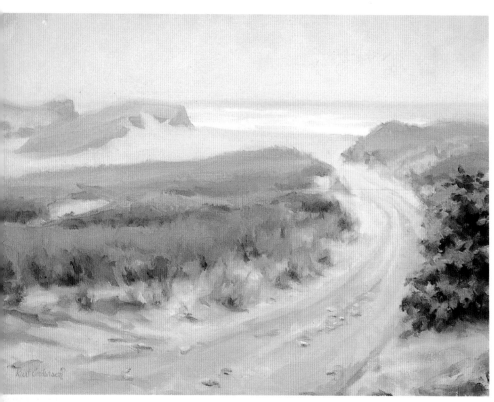

Fog and haze are an almost daily occurrence on Nantucket Island, and as an artist I was intrigued by their effects on receding vistas. The biggest problem in painting these effects, of course, is that they would continually change. As the sun would rise in the sky, the haze would burn off. The best solution I found was to start by painting the most distant objects. Distant objects are usually the fastest things to paint anyway. As the haze lifted I would move forward in the picture, until by the time the haze was completely gone, I would only have the most immediate foreground objects to complete. These are the things least affected by the haze anyway, and by making them more distinct, the character of the haze was actually emphasized to better effect.

Miacomet Beach, 12″ × 16″

I had the same problems in painting this Nantucket meadow as I did in painting the beaches. The wind was actually blowing very fiercely, bringing mist across the scene in waves. Since nothing ever looked the same twice, I had to be content in painting an amalgam of impressions.

Sanford Farm, Nantucket, 9″ × 18″

One of the great advantages of working on small-scale sketches is that it forces you to simplify detail. The challenge is to transfer this quality of simplification to works on a larger scale. One helpful procedure is to put "wasteful" quantities of paint on your palette. They're not wasted, after all, if it helps you to produce superior paintings. Another trick is to use the largest brushes you can possibly get away with. I always proceed by massing in only the broadest shapes and values at first, with the idea that I can always come back and add as much detail as I want. What surprises me is how little detail I usually have to add to make the picture work.

Northern Peaks, 22″ × 28″

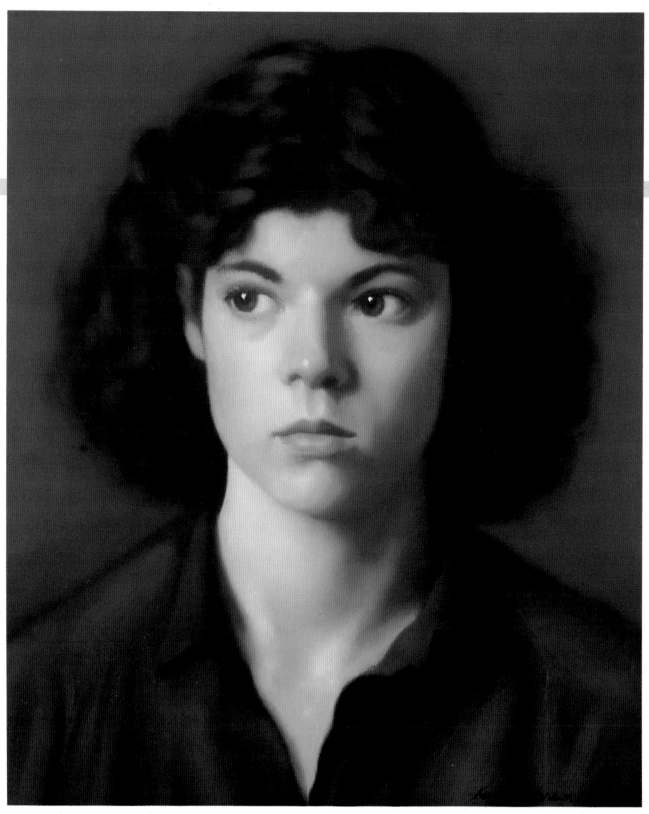

This head study is an example of the degree of finish and subtlety of form that can be achieved using the layered method. I call this technique a *searching* style of painting, since it allows you to alter and improve the picture with each successive layer.

Elizabeth, 17" × 14"

Painting the Human Form

Up until at least the mid-nineteenth century, historical painting was considered the highest form of painting. Most art students aspired to paint large pictures full of figures depicting religious, historical and mythological subjects. For many years in France these were the only pictures featured at the great annual salons, and it was only the painters of such pictures who could hope to become one of the honored, state-supported academicians.

It was for this reason that the primary objective of traditional academic and atelier art training was to learn how to paint the human form. Every exercise was designed to prepare a student for this skill, even though it might be many years before a student would be allowed to even try it.

Today there are few traditional painters producing historical pictures. Yet learning how to paint the human form remains the primary objective of traditional training. This knowledge is obviously essential for painting genre scenes and portraits, but beyond that, learning to paint the human form forces you to integrate your skills to the extent that you can successfully paint just about anything else.

THE HEAD STUDY

Painting head studies is the best way to ease yourself into this enormously difficult task of learning to paint the human form. I use the term "study" because it suggests a painting in which you make a simple, accurate record of what you've seen. A portrait, on the other hand, suggests a larger scope—a statement made through gesture and expression, composition and color. But you don't need to tackle all those elements at first. Simply start with head studies.

The layered method of painting, which I discussed in chapter four, is the best method for first painting head studies. It allows you to employ what I would call a *searching* style, as opposed to a *spontaneous* style. Da Vinci used a searching style when he painted the Mona Lisa. He had a vision of what the painting should look like and he worked over his canvas until he achieved it. Only with a searching style can you get the kind of profound subtleties associated with artists like da Vinci, Titian, Rembrandt or Van Dyck.

Examples of the spontaneous approach to portraiture can be seen in the works of Velázquez, Frans Hals and John Singer Sargent. Instead of searching for the perfect vision, these artists allowed the brushwork and happy accidents to remain. With this approach, the surface of the picture itself often holds the greatest interest. Looking at the brushwork, you can enjoy the virtuosic performance of the artist.

As students, however, these spontaneous artists produced portraits that were highly finished and refined (searching in nature). Their style became looser only after they matured. If you want to emulate the bravura brushwork of these masters, keep in mind that their paintings are successful because the drawing, color and design are done so well. The deft brushwork is simply one more element, which works only because the foundation is rock-solid.

So as you begin your head studies, try the searching style. It allows you to carefully analyze your painting and improve with each effort.

SETUP AND DRAWING

A head study should be painted using the sight-size method described in chapter two, meaning that you paint the head the exact same size that you see it. If my painting is to be life-size, for instance, I'll place the easel beside the sitter. If I were to look along the edge of my canvas, it would bisect the face, with the nose and chin sticking out in front of the canvas and the rest of the head behind it. All of my observations are then made from a point several feet in front of the easel. I have to step up to the easel to paint, and step back to look. I usually mark the spot where I make my observations with a piece of tape so that I always stand in the same place.

Before you actually start to paint I recommend making a drawing, like the head drawing demonstration in chapter three. Begin by holding a string horizontally and at arm's length. Note where certain points of your subject fall on your paper, marking the top of the head, the bottom of the chin, the corner of the eyes, etc. It is important to work with the utmost care, even at this early stage, because what you do at this stage will determine the eventual course of your painting. If you are having trouble establishing the shapes in the drawing, you should take the time to work them out before moving on to the painting.

After the drawing is finished, place tracing paper over it and make an outline. Then retrace this outline onto the canvas using graphite paper. As you begin to paint, the basic drawing is already established and you can concentrate on getting the color and value right.

BALANCING WARMS AND COOLS

When painting heads it is important to make note of the delicate balance between warm notes (colors that tend toward yellow and red) and cool notes (colors that tend toward blue). This delicate interaction between warms and cools is what gives a portrait life.

First, I try to capture the general balance between warms and cools as they appear on the head as a whole. When using natural light in a studio, the shadow side of the face is generally warmer than the light side of the face. The coolest halftone will generally be found in the neck on women and children, and in the bearded area on men.

I also want to capture the interaction between warms and cools within more specific areas. There's always a lively interplay between warm and cool notes within the light area of the face. The halftones on top of the nose and surrounding the nostril, as well as on the cheekbone, will tend to be warmer. The ears will also present a warm halftone note.

Comparing Warms and Cools
Whatever area I'm painting, there will usually be a lively interplay between the warm notes and the cool notes. Compare the cool flesh notes in the neck to the warm flesh notes in the upper cheek in this detail of *Elizabeth* (seen on page 76).

Warm and Cool Shadows
Shadow areas are coolest near their edges, at the transition from the light to the shadow, and are warmest toward the middle of the shadow. This is because the shadow picks up warm notes reflected into it. Throughout the painting as a whole, the shadow areas should be warm compared to the light areas, as seen in this detail of the portrait on page 85.

DEMONSTRATION

A Head Study

THE LAY-IN

Since I use the layered method when painting head studies, I begin by mixing the color notes generously with paint thinner to the consistency of cream. I follow my normal procedure of putting down the darkest notes first, because they're the easiest to see against the white canvas. I then progress to the middle values, adding the lightest values last. My goal with the first sitting is to get the entire canvas covered.

It's important not to finish any particular area of the head at this stage. Instead, I concentrate on making the individual parts relate correctly to the whole. I leave all of my edges blurred so that I must resolve them in the subsequent layers, when I can do it more intelligently. I try to resist the temptation to smooth over the brushwork or to follow an edge with the brush. That will only muddy the immediate color impression.

Step One—Cover the Canvas
At my first sitting my objective is to get the canvas completely covered. I mix my colors generously with the paint thinner so that they have the consistency of cream, and I begin by putting down some of the darkest notes since they are easiest to judge against the white canvas.

Step Two—Keep the Edges Fuzzy
I proceed to the lighter values since I can now see what they should be in contrast with the dark notes I've established. I keep all the edges fuzzy and the brushwork fractured. I refrain from resolving them until later, when I can do it more intelligently. I allow this to dry over a couple of days before proceeding to the next layer.

BUILDING UP LIGHTS

One of my objectives with the second layer is to build up the lights. I want the light areas to have more texture, so I apply the paint more thickly. Although I usually mix in a little medium, I also use the paint as it comes directly from the tube, especially for the highlights.

I allow the brushwork to follow the form to some degree so that the texture expresses the form. This is usually most noticeable in the highlights beneath the eye and above the brow. Light hitting this texture creates a slight shimmer, offering a more luminous effect in the lights.

As I build up the lights with the second layer, I also concentrate on the modeling. I want to capture greater unity in the modeling, while at the same time maintain the rich color I initially achieved. Another objective is to work out problems with shapes. I make some slight adjustments in the mouth, the left eye and the bottom of the chin. However, I don't attempt to finish these areas. I simply put enough paint down to work out the problems, keeping in mind that the entire painting will once again be covered with the final layer. Then I work out the finer points in drawing and modeling.

When working on shadow, I'm careful to keep the paint thin, since the texture left by thick brushwork picks up light. On the light side, careful modeling and brushwork help express the form, whereas on the shadow side, the form is lost. The dictum among classical artists is to make shadows "flat and liquid."

The acknowledged master of flat, liquid shadows was Rembrandt. If you look at a Rembrandt head, espe-

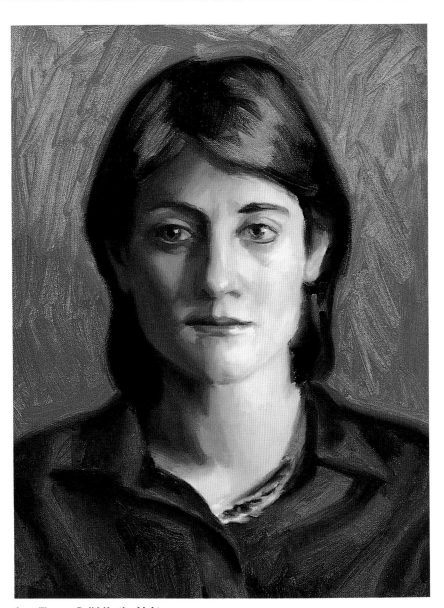

Step Three—Build Up the Lights
In the second layer, I build up the lights with thicker paint so it will catch the light and be that much more brilliant. My objective is to take what I've already done and improve on it. Here, I wanted to create greater unity while keeping the rich colors of the first layer. I didn't finish any areas, because I knew I'd be covering them in the next layer.

cially his early work, you'll notice that shadows are painted with thin glazes, without any of the rich brushwork characteristic of the lights. Within these shadows, the form disappears; you see only hints of warm, reflected light.

You'll see the same contrast between the handling of light and shadow exists in these examples, if not quite to the same degree. Re-flected light is usually painted with an orange-red note. Shadows are always warmest toward the middle and cool along the edge near the light. The reflected light within the shadow constitutes the warmest note in the picture.

After I mass in the shadows, I also try to refine the transition along the shadow line before the paint dries. This is especially evident in the forehead, where I've darkened the halftone considerably where it meets the shadow. When painting this area, I didn't actually look at it. I kept my eyes focused slightly lower on the face and tried to capture what it looked like out of the corner of my eye. If I had painted the transition to the shadow line as it appeared when looking directly at it, I would have made it too hard.

Detail
To build up the lights, I use little or no medium in my colors and apply them thickly so that you can see the brushstrokes. This is most noticeable in the highlights beneath the eye and above the brow. Light hitting this texture creates a slight shimmer, offering a more luminous effect in the lights.

Detail
Form is not expressed in shadows nearly as much as in the lights. The rule is to make shadows "flat and liquid," so I add considerably more medium to my colors than I do in the lights. This way the paint remains thin and is free of obvious brushwork.

The Finishing Stage

For the final layer, I thin my paint with more medium so that it adheres to the layer beneath. Of course, when insufficient medium is used, the paint becomes chalky when it dries and loses its original color. I often use retouch varnish to restore that original color and sheen as I'm finishing.

Because the shapes and colors have already been established, I am able to model with much greater subtlety in the final layer.

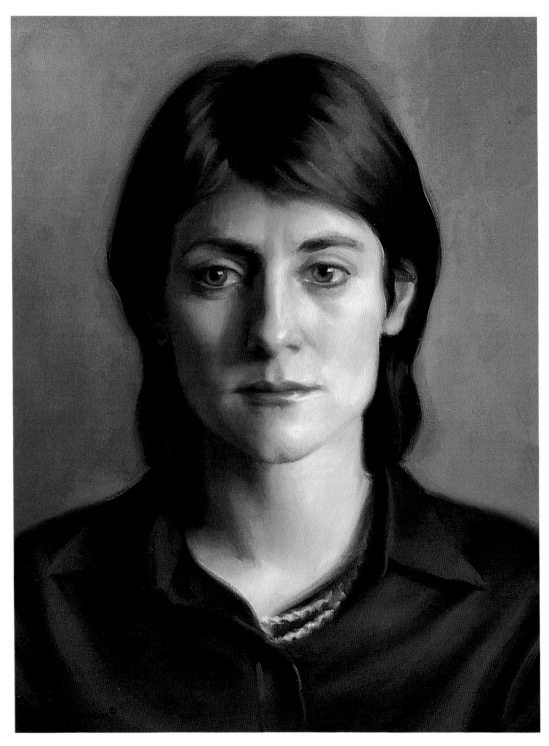

Finish
To finish the 16 × 12-inch study of Margaret Coyle, I carefully refine the shapes and create variety with accents, which I find by squinting or by looking out of the corner of my eye. I finish modeling the light side of the face by covering the entire area with a glaze of a middle tone mixed with a generous amount of medium, then repaint it by mixing the colors into that glaze.

The colors I used for the demonstration are: ivory black, raw umber, alizarin crimson, cadmium red light, titanium white, lemon yellow, Naples yellow, yellow ochre and ultramarine blue. This illustration shows the combinations I used for the various fleshtones.

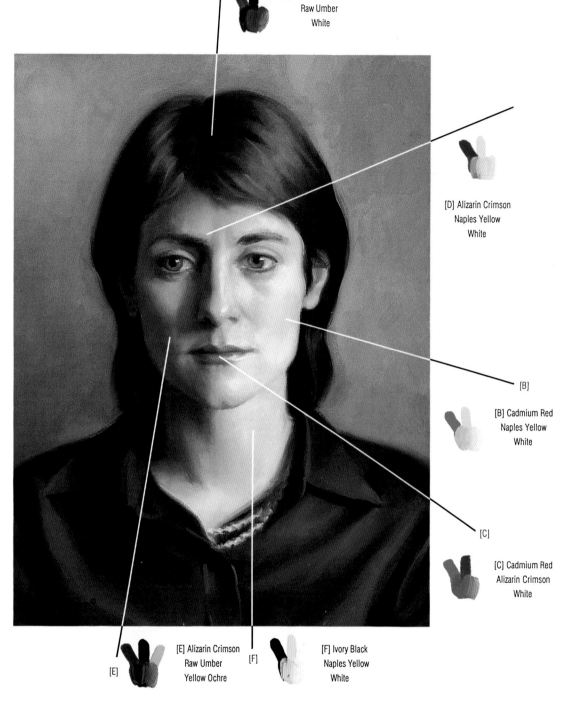

[A] Alizarin Crimson
Raw Umber
White

[D] Alizarin Crimson
Naples Yellow
White

[B] Cadmium Red
Naples Yellow
White

[C] Cadmium Red
Alizarin Crimson
White

[E] Alizarin Crimson
Raw Umber
Yellow Ochre

[F] Ivory Black
Naples Yellow
White

MIXING FLESHTONES

Whatever halftone in the face I'm trying to capture, I usually mix it with only two colors plus white. In the demonstration, I usually began by reaching for Naples yellow, mixed it with white, and then combined it with one other color. This was because the model's complex-ion was fairly pale and cool. (In the case of a more olive or tan complex-ion, I would have started with yellow ochre.) The cool notes were almost all made by adding just a bit of ivory black to the Naples yellow. The warm notes were generally made by adding cadmium red.

I first tried to achieve the note with one or the other of these two combinations. If I didn't succeed, I added one other color from my palette. If that still didn't achieve the desired color, I cleaned my brush and tried another three-note combination. I try to avoid simply adding more color to what I've already mixed: The result is usually less rich and pure than what the note should be.

The subtle modeling that you see in the light side of the face was achieved by using a technique called scumbling out. After unifying the entire halftone area by scumbling a glaze over it, I repainted the area by mixing my colors into the glaze.

Jay, 23″ × 17″

SCUMBLING OUT

I don't always need a lot of paint to finish the light side of the face. Often the colors, values and shapes are close to what I want, but they lack subtlety in the modeling. Everything is still a little too jumpy. So I'll finish that area using a technique called "scumbling out."

First I mix a value halfway between all the values in the halftone area, and I mix it generously with medium. I then scumble this "glaze" over the entire halftone using a rapid back and forth motion with the side of my brush. It doesn't completely cover what's underneath, but gives it all unity. I then repaint the entire area mixing my colors into this glaze. This technique is useful because the glaze initially helps you see a more unified whole, and it also modifies and unifies the colors mixed into it.

THE RIGHT ACCENTS

This effort to capture more unity may contrast, however, with the way I paint the eyes and the mouth in the final stage of a painting. I allow my eye to focus on them a little bit more, because these features are much more a center of interest for viewers. As important as it is that you *not* focus on everything as you paint, it's also important that you *do* focus on some things. Otherwise, the picture will simply look fuzzy. A painting without accents is analogous to singing or talking without accents: Without putting the stress on certain words you sound very monotonous.

With any subject observed as a whole, certain things will attract your attention, and these things should be stressed as accents. In a head study you want to stress the eye, nose, and mouth on the light side of the face. There are various accents within these details as well, especially where one contour overlaps another.

I also find certain points to stress along the outside contour of the face and hair. For example, the contour along the hair as it meets the background is soft in most areas, but you always want to bring it into focus in places to add variety.

Of course, you will see all of these contours in focus when you are actually looking right at them. I achieve variety by seeing which things capture my attention while looking at the picture as a whole. I then consciously choose to focus on some things, and not on others, while I paint them.

THE NEXT STEP

The principles involved in painting head studies are very much the same for painting a more complete human figure. In a traditional atelier you would eventually use the techniques I've discussed in this chapter on a much larger figure study.

Of course, for someone working on his or her own, the logistical problems of studio space, and getting someone to pose, make figure painting a difficult endeavor. But there are often a variety of options. Local colleges and art centers frequently offer figure drawing and painting sessions, where you can share the expense of hiring a model with several other artists.

Detail
When I finished the detail in this face, I would usually concentrate on only one feature of the face during each painting session. For instance, I would scumble a glaze over the eye area only, and then entirely repaint this area so that it looked like it was painted freshly and with unity.

Painting From Life

This painting is an example of the highly finished figure work we would attempt as a final lesson in the atelier curriculum. This painting was done entirely from life over the course of about twelve two- to three-hour sittings. I didn't make my model hold his hand up all the time I was painting him, of course, but when he did there was a sling suspended from above for him to rest his hand in. For his right arm I devised a shelf for him to rest his elbow on. The shot was actually a coconut painted black.

The Shot-Putter, 28″ × 29″

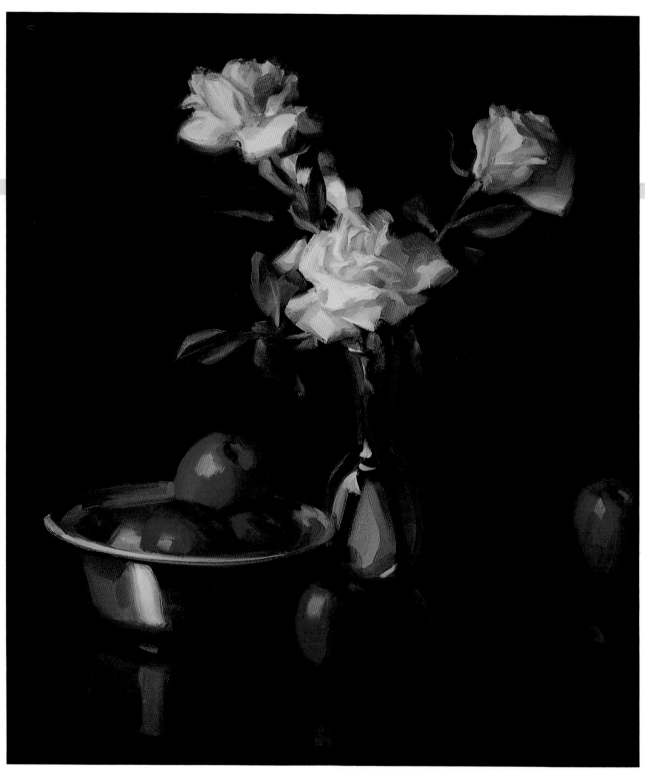

The alla prima method was used to paint this still life. I worked directly on a blank canvas and finished the entire picture in one session. Since what I initially put down was altered very little, this method reveals the natural, unself-conscious brushwork.

Still Life With Roses and Apples, 24″ × 20″

The Painterly Touch

A classical guitarist whose portrait I was painting asked me what were the greatest technical difficulties for a painter. Watching me paint the neck of his guitar, he was impressed by the long sustained strokes that I used. He practiced various finger exercises on a daily basis in order to keep his skills honed, and he wondered whether I also engaged in exercises to develop my dexterity.

But I had to disillusion him. I had never done any exercises to develop my dexterity at brushwork. It is not that difficult to touch a brush to canvas, I told him. What is difficult is having the right color at the end of the brush, and knowing where to put it. If I have a greater ability to draw a straight line than my nonartist friends (who always complain that they can't), it isn't because I have made any special efforts to develop that skill. There are certain technical problems along these lines one must learn and overcome, but the real technical difficulties in painting are of a different nature.

CONFIDENT BRUSHWORK

As I've said before in this book, learning how to paint is, more than anything else, learning how to see — being able to properly identify in your mind the actual shapes, colors and values of your subject. You must learn how to hold a brush, prepare a canvas, mix colors, and a host of other things, but the real, technical limitations for artists are almost always presented by not being able to see.

Dexterous and virtuosic brushwork is therefore an outgrowth of this skill. It is not self-conscious. It is a natural consequence of being able to see the shape and the color with such certainty that you can mix the color on your palette and hit it the first time with one stroke of the brush.

It might help in explaining what brushwork should be by explaining what it shouldn't be. It shouldn't be mannered and ostentatious. Illustrators often fall into this trap, especially when they work from photographs and need to transform static reference material into something that looks more "artistic." This sort of brushwork draws attention to itself, and you can sense that the artist carefully labored over each brushstroke for optimum effect — to make it look, in fact, like it was painted without labor.

I think that the best brushwork arises when you are not worried about what the brush is doing. It hap-

Detail
The best brushwork actually occurs not when you are preoccupied with what your brush is doing, but when you are preoccupied with what it is you are seeing. Painting this lacework on a dress collar (see portrait on page 120) was really a process of seeing the larger values and colors that the lace created. Once I massed those in I added just enough accents to suggest the pattern.

Detail
Separated from the picture from which it came (*Northern Peaks* on page 75), this close-up of a tree does not look very tree-like. That is why you must continually step back from your picture as you paint and see what it looks like as a unity. Within the proper context, all it took to define this mass of color as a tree was a little detailing on the outside contour.

Detail
Character and realism are not necessarily expressed by finish and detail. You can achieve these things working very broadly provided that you paint what is essential. Fleshtone colors must be painted richly with a lively interplay between the warms and cools. And even though the modeling is very loose, you must still be careful not to overexaggerate variations in the values. See the whole portrait on page 126.

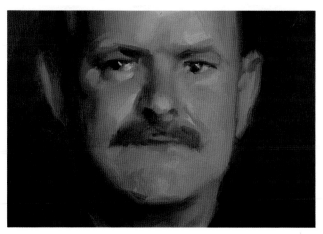

pens when you are preoccupied, instead, with reproducing what you see. This is what I mean when I talk about "letting nature paint itself." The act of painting becomes more and more an automatic extension of the act of seeing. Greater dexterity in brushwork is achieved, therefore, by breaking down the barriers between painting and seeing — by allowing that initial touch to the canvas to remain as unaltered as possible because it expresses so well what you saw.

The alla prima method — painting directly on canvas and finishing while the paint is still wet — is the most spontaneous method of painting. What you initially put on the canvas is altered less when using this method than any other, and it therefore reveals that natural, unself-conscious brushwork, more than any other.

PAINTING STILL LIFE

Although I have already discussed the alla prima method in chapter five, learning to use it on a larger scale is best done painting still lifes. The colors and values you see when working on still lifes are more constant than when working outdoors. You also have more control over the composition: After you've arrived at a setup, you simply paint what you see.

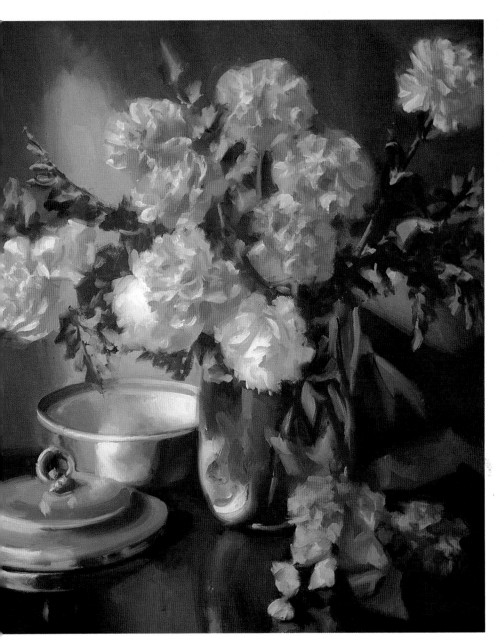

Develop Your Skills With Still Life
Painting still lifes is an excellent way to develop your skills in alla prima technique. Still lifes allow you to work out all the problems in composition just by moving the different elements about. A still life has the potential of being a perfectly composed scene on which the light alters very little over the course of a day. So when you frame the scene in a viewfinder, you can take your eye out of focus and see the entire picture as a unit, and then paint precisely what it is you see.

Still Life With Pink and White Carnations,
24″ × 18″

TRANSLUCENT AND OPAQUE TECHNIQUES

When putting paint to canvas, you can apply it thinly either by adding more thinner or simply by using less paint to cover a larger area. Of course if you apply paint thinly the white of the canvas will show through, making the color appear lighter. If you use a lot of paint on your brush and apply it thickly, it will completely cover the canvas. But thick paint will also show your brushstrokes more as the light reflects off the ridges left by the bristles.

When you are trying to establish a dark note this process works against you. The thicker you apply the paint, the more it shimmers with reflected light. The thinner you apply the paint, the more the canvas shows through.

GRINDING IN

So how do you achieve a dark, flat value note? I use the brush technique which I call "grinding in." This technique can be seen in the following demonstration where I use premixed black and a little alizarin crimson to paint the darkest notes. Using a large bristle filbert, I make a mixture of these colors without any thinner. With only a little color on my brush, I apply it using a back-and-forth scumbling stroke. I essentially push the color into the canvas, tinting it as dark as it will go without the paint building up. The note wasn't as dark as I wanted it at first because the canvas still showed through, but it was dark enough for me to proceed with the rest of the painting.

After the rest of the picture is covered, I can come back and get the dark notes as dark as I want them. The color soaks into the canvas and sets up enough by that time that all it takes is a repeat of the same "grinding" procedure to make

the note dark enough. This procedure doesn't completely eliminate reflective brushstrokes, but I like a little expressive brushwork even in the shadows.

RICH COLOR

One thing you will notice is that there is a certain richness to your colors when the canvas does show through. This is one of the great advantages of working alla prima. You can take advantage of the translucent properties of your paints, making colors much brighter and richer than if they were painted opaquely.

This is helpful with some of the richer colors within the shadows. It is often difficult to make colors that are dark enough, and yet retain the proper richness of hue. In painting red roses I often use the transparent properties of alizarin crimson in the shadows. All the variations of color are achieved, in some cases, simply by how thickly or thinly I apply the paint. Sometimes I achieve variety in my shadow notes by using a dry brush to pull off paint where I want more red to show through.

INTENSE COLOR

Transparent techniques are also helpful in painting some of the brightest notes in the picture. It is a challenge to achieve the intense reds necessary for red roses in light. In addition to the cadmium red that I usually put on my palette, I have found it necessary to utilize geranium lake, a bright violet-red, for the purpose. But if I were to simply add white to the red hue that I've mixed to make it bright enough, I would lose the intensity of the hue. So instead I paint it thin enough so that the canvas shows through.

I don't like to use transparent techniques, however, when painting highlights. As I've mentioned before, highlights are the brightest notes in the picture where light is

reflected directly from the light source into your eye. Because of this the hue is often very intense. It is so intense that if you add white to your color to brighten it, the hue is almost impossible to achieve. And yet I like painting highlights with thick paint. I want the highlight to have texture, and to stick out above the surface of the painting and catch whatever light is hitting the picture. This is the only way to give highlights the punch they need.

So in painting highlights I sacrifice the intensity of hue that I could achieve if I worked transparently. I find, however, that the eye is easily fooled into thinking that the highlight has the full intensity of hue if the values surrounding the highlight do. So the combination of transparent middle values leading to opaque highlights provides a rich interplay of color and texture that makes the flower heads look luminous.

Transparent color should be used only where it is needed. Flowers of a lighter value, like white or pink, should be painted very opaquely. The color notes in flowers of this value are usually not so intense as to cause any trouble achieving them. By using unthinned paint and a fully loaded brush I get a lot of texture in the brushstrokes. This texture picks up the light and can provide a nice contrast with the more darkly and flatly painted areas of the picture.

One major difference between the alla prima method and the layered method described in chapter four is that you don't start by making a preliminary drawing. You start with the canvas already stretched, so you don't have the luxury of choosing the size of the canvas after making a drawing. Instead I suggest that you use a viewfinder with the same proportions as your canvas, and then set up the still life to fit those proportions.

[A] To paint this tulip I added geranium lake to my palette. I use it very sparingly, because it is not a very permanent color. But, I find it is essential to achieve these violet-reds and some of the reds you find in deep red roses.

[A]

[B] Because this flower is the brightest note and the center of interest, I painted it with much thicker paint. I allowed the paint to form little ridges, especially along the edge of each petal, so that the light would catch these highlights. [B]

[C] This orange note was achieved very simply by adding a little lemon yellow to my cadmium red. It looks as rich as it does because I painted it thinly allowing the white canvas to show through.

[C]

[F]

[D]

[E]

[F] Some of the most interesting brushwork is achieved when you create an interplay between the lightest notes painted very thickly, and the darker notes painted more thinly. The contrast creates a sense of three-dimensionality.

[E] When I painted the highlights as they are reflected in the tabletop, I kept the paint thin to make them look separate from the surface of the tabletop. This is done to show that the reflections are always out of focus. The tabletop itself has a different point of focus than the reflections in it.

[D] Highlights are almost always painted with thicker paint than the surrounding value. This would seem to disturb the smooth surface of the glass I was trying to capture, but by making the highlight thick I am actually giving it greater focus, and thus emphasizing the reflective nature of the glass.

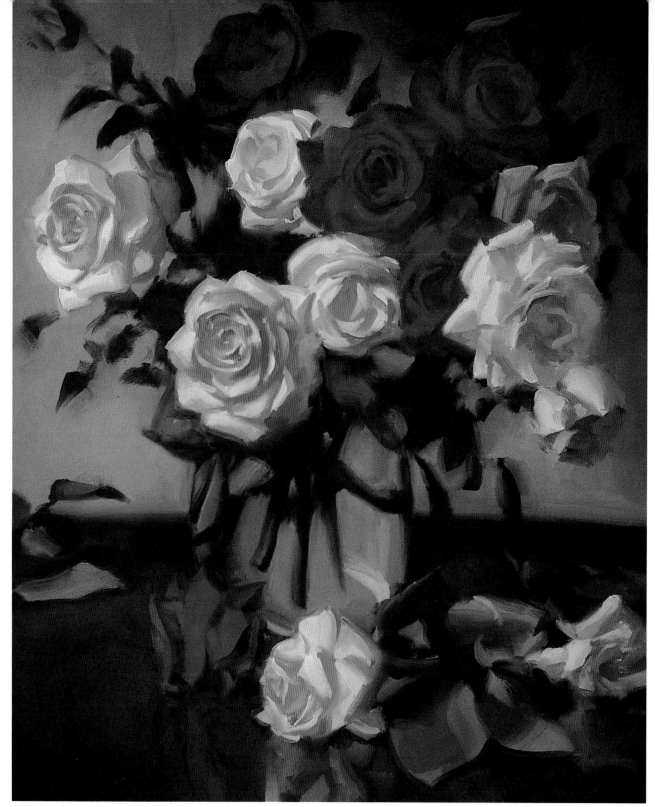

Achieve Rich Brushwork

I like the rich variety of brushwork that can be achieved by working both transparently and opaquely. It works especially well in this painting where the thinly-painted roses in the shadow contrast nicely with the thickly-painted roses in the light. The thick paint also complements the weight and droopiness of those particular flowers.

Red and Pink Roses in a Glass Vase, 24" × 19"

Detail
Generally, the darker the note the more thinly it is painted. This doesn't necessarily mean that you add more thinner to your colors. It just means that you don't lay the color down as thickly. Because the colors are slightly transparent, the white of the canvas beneath may show through. But, this has the advantage of enriching the colors, a factor which helped me in achieving the rich violet-reds of these roses.

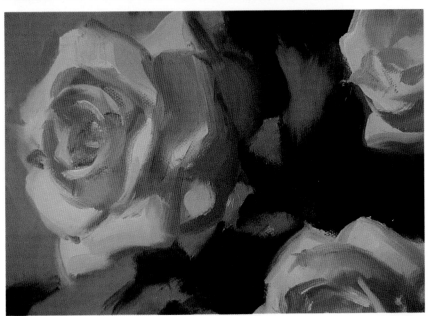

Detail
The procedure of working from the darkest notes to the lightest notes is one I often diverge from when working on individual flower heads. Because lighter notes are easily muddied by darker ones, I don't want to have to work a lighter note back over a darker one that has already been applied. So, I like to apply the lightest notes in the flower head first, and then work the darker notes into it.

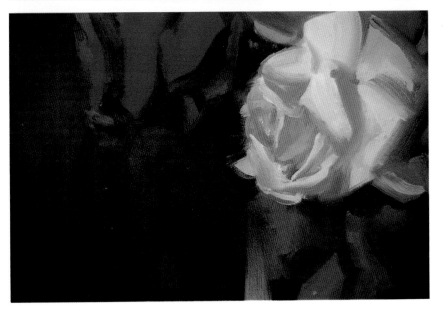

Detail
When painting a dark area like the top of the table, I like to "grind" the paint into the surface of the canvas. It's like staining the canvas with an unthinned color, without letting the paint build up. Once I get the basic color established, I add the variations created by the reflections. It took only a little more alizarin crimson in my paint to create the rich reflection of the red rose.

DEMONSTRATION

Painting a Floral Still Life

SPOTTING IN THE DRAWING

Since the drawing has to be worked out directly on the canvas, I like to start with a very light wash made with the thinner and just a hint of color. I block out my drawing much like I described in the chapter on drawing, but I do it very freely. I keep the wash so light at first that I can barely see it on the canvas, but as I become more confident about the placement of the shapes I make the wash increasingly darker.

When I feel that the drawing is sufficiently established, a transition occurs in my approach. Using only a little thinner in my mixtures I start establishing some of the darkest value notes in the picture. When working with a blank white canvas I always start by massing in the darkest values first, because the lighter masses of value do not make sense when seen against the even lighter white of the canvas.

This is a rule I frequently break, however, when painting floral still lifes. I sometimes mass in the bright value I see when looking at the flower heads even if they are lighter than the background. It is simply easier to represent those light blobs of value by a single mass, rather then by laboriously outlining them.

It also allows me to work out the shapes of the flowers a little before putting down the darker background value, which even in a wash form would pollute the flower values if I made a mistake and accidentally overlapped into a flower.

Once the flower shapes are plotted, however, I start following my normal procedure. I mass in the darker background as a negative shape around the flowers, and in the process of doing this I dig out the shapes more precisely.

Demonstration Palette
When working alla prima it is best to use as few colors on your palette as possible, but they should be applied generously. I used the following colors in the demonstration: On the far left, a mixture of half ivory black and half raw umber; next, geranium lake (a color I use specifically for red roses to achieve some of the richer violet-reds); finally, to the right, alizarin crimson, cadmium red, titanium white, lemon yellow, yellow ochre and ultramarine blue.

Step One—Do a Light Wash Drawing
I begin by making a light wash drawing of the still life. I add just a little alizarin crimson to a lot of paint thinner and quickly work out the dark notes that define the flower shapes. I use raw umber for the other notes. I am careful to keep colors light so whatever I put down can be easily amended later.

After putting in the darkest masses of color, I move on to the middle values, and when I get those roughly established I move on back to the lightest values of the flowers. Now my objective is just to first get some value down over the entire canvas. I take my eye out of focus and look for the big shapes of value, and I paint these big value shapes with as much simplicity and unity as possible. I don't worry about the detail because I know that I can come back later and bring as much detail as I want into whatever I've already painted. But it is difficult to tell just how much detail I will need until I can see the entire picture as a unit, with all the masses of value established to at least some degree.

Step Two — Mass in Dark Notes
After I feel comfortable with the drawing, adding little or no thinner to my colors, I mass in some of the darkest notes that I see. The flowers were painted with alizarin crimson and a touch of ivory black. The stems and leaves were made with ultramarine blue, yellow ochre and a touch of alizarin.

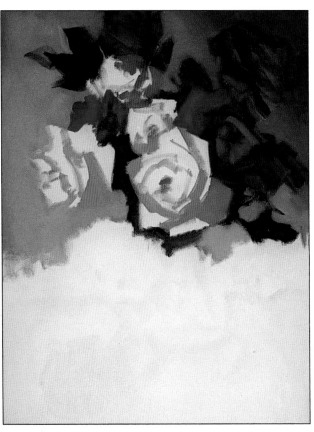

Step Three — Paint Middle Values
With the dark notes established I proceed to some of the middle values. The shadow notes in the pink roses were made mainly with white, ivory black and alizarin. I paint about halfway down the canvas because I determined that I could only finish that much of the painting during one day of work. With the alla prima method, you essentially finish whatever you've started the same day, while the paint is still wet.

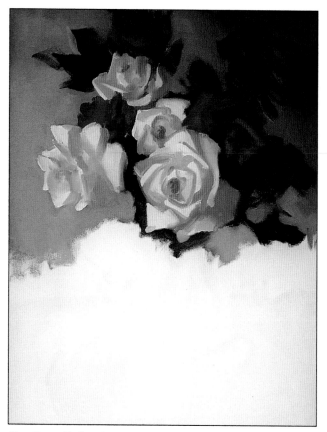

Step Four—Refine the Flower Heads
The whitest notes in the flowers were made with white and just a touch of cadmium red. Using a thickly loaded brush I massed them in so that they overlapped a little the areas where they should be. I was also careful to keep the shadow notes within the flower heads themselves a little on the light side, since it is easier to add dark notes to lighter notes than it is to lighten notes which are too dark.

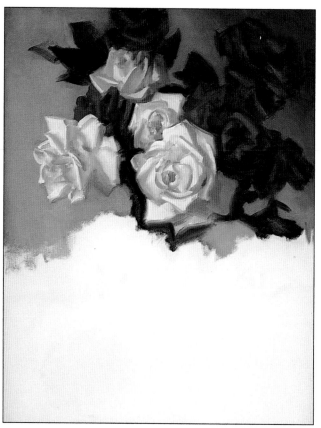

Step Five—Add Detail
Once the area I am working on is entirely covered with paint, I go back and add detail. I darkened the shadow values in the pink flowers and added accents, while at the same time digging out the shapes of the petals. I also refined the dark red roses a little more by darkening the accents and lightening the brighter notes. This was sometimes done just by lifting a little paint off so that more of the canvas showed through.

WORKING DARKS OVER LIGHTS

When painting the lighter values in your picture, you have to take precautions so that the color doesn't get polluted. I mentioned earlier that I like to take my eye out of focus, paint the broad masses that I see, and then add detail later. But I adjust this procedure when dealing with the lighter and more intense areas of value, such as flower heads.

When you are dealing with extremely light and intense values, it is difficult to achieve that intensity if you already have a value down which is darker than you want. The darker value will muddy whatever you put on top of it. This usually isn't a problem when dealing with the darker areas of the picture. As you put more detail into the darker areas you simply adjust the color notes that you mix to compensate for the slight muddying that occurs.

But for the brightest and lightest notes in your picture, you want to avoid any polluting of the color note.

So, in a sense, I don't use quite as much freedom when painting a flower head. Instead of painting the broad value I see there when my eye is out of focus, I paint only the brightest value that I see, allowing that bright value to overlap into the darker details of the flower. I then work in some of the medium values, digging out the detail as I go along.

I put in the darkest notes only at the very end when I feel fairly secure about the shapes I've established with the lighter notes. This is backwards from my normal procedure, but this way I avoid polluting the lightest notes.

ESSENTIAL DETAIL

When working on the detail in the flower heads you will still want to take your eye out of focus, from time to time, and look at what you're painting as a unit. For one thing, it is difficult and unnecessary to paint all the detail that you see in the flower. Some of it will have to be simplified. Furthermore, the center of interest should have the greatest focus and detail. But as you move away from the center of interest, the flowers should be a little more broadly painted, and there will be some flowers along the periphery and in the shadows which should have very little detail at all. The more your eye is out of focus, the more likely you are to capture the unity of what you are seeing.

Once the flower heads have been painted in, I proceed around the picture putting detail in where I think it needs it most. I'll dig out the shape of a leaf and then move to somewhere else entirely, perhaps the vase, and put a highlight there. I never allow myself to become involved too much in one area, because chances are I'll give it more detail than it needs.

What I'm doing, in a sense, is starting from a situation in which there is too much unity. I work around the entire picture adding detail wherever I think it is needed most to mitigate this problem. And then I stop when it is no longer a problem.

What surprises most people is how little detail they need to make a picture look very finished. A problem for most beginners is that they put more detail into their pictures than is necessary. It is always more difficult to bring unity into a picture that doesn't have it than it is to bring more detail into a picture.

Besides, putting detail in a picture takes a lot of effort. A painting in which the artist has put too much detail, and then had to paint it out, is hardly going to look effortless. Effortless, virtuosic brushwork comes when you can bring a painting into existence from a state of unity to detail without ever overreaching your mark.

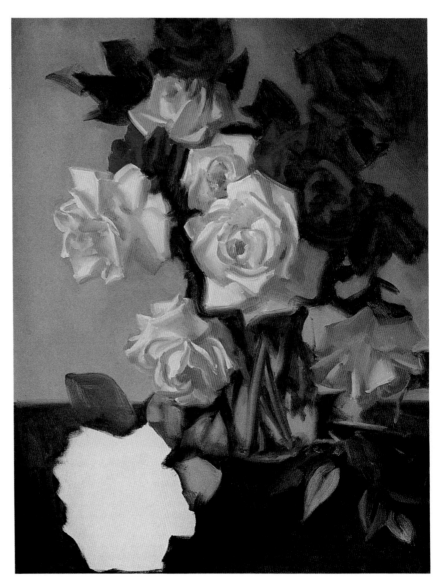

Step Six—Paint the Whole Tabletop
The next day that I worked on this painting, I followed the same procedure but didn't have quite enough time to entirely finish it. I decided early on that I could complete all but the two flowers on the table, so I simply left that area blank. I painted the entire tabletop so that it would be unified in appearance.

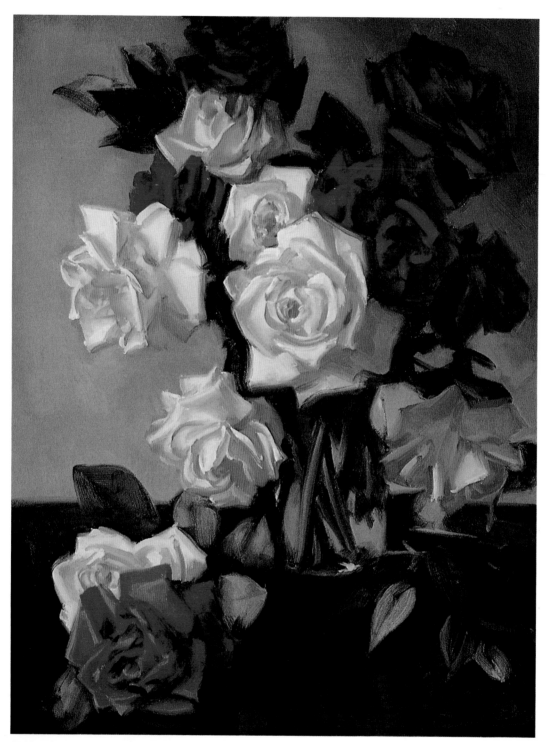

Finish—Paint the Remaining Flowers

In finishing the two remaining flowers I had to also repaint a little of the sur-
rounding area—taking care to conceal the seam that this created in the shad-
ows. Even though the rest of the painting had dried, I was still able to make a
few additions. Mixing a little medium into my colors, I added some dark notes
to the darkest flowers and put some more reflections in the tabletop.

Paint Only as Much Detail as Needed

There is an enormous amount of detail that could be painted when painting a vase full of carnations. The trick is to paint only as much detail as is needed. I begin by establishing only the broadest values at first, getting the entire area I am painting covered. I then work around the painting adding detail, starting with the center of interest and working out. When there is enough detail to suggest the character of the flowers, I stop.

Carnations in a Pitcher Vase, 28″ × 23″

Contrast Textures and Surfaces

Contrasting textures and surfaces adds a great deal to the charac-
ter of still lifes. It is also interesting to contrast the same objects
in altered circumstances, comparing them to their reflections or
obscuring them by such things as a plastic bag. I think that is
what fascinated me when my wife placed these nectarines on the
counter after grocery shopping one day. She let me have them
on the condition that I would spend only one day on the painting.

Nectarines, 20" × 16"

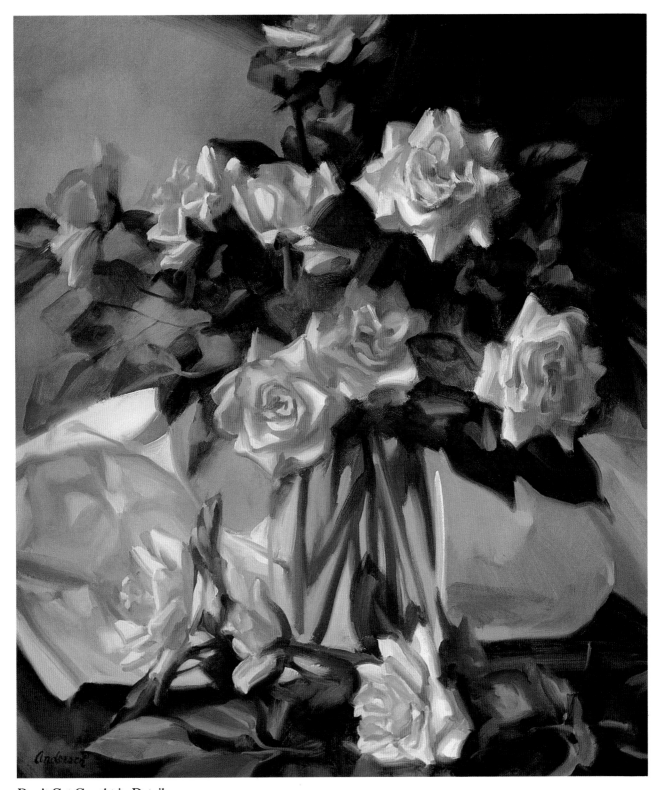

Don't Get Caught in Details

There is actually an enormous amount of detail in a still life
setup such as this, and if I wanted to I could spend months
painting it. I avoid getting bogged down in detail, however, by
painting only the most generalized masses of color that I see. I
then work detail into these broad masses of wet paint. When I
have just enough detail to express what I see, I stop.

Still Life With Yellow and Pink Roses, 26″ × 22″

BASIC COMPOSITION

Students sometimes assume that a successful still life depends entirely on technique, but good composition probably plays the largest part. In fact, still lifes are ideal for learning the basics of composition.

In painting a landscape, for instance, it's impossible to find a perfectly composed scene. The various elements must be altered in some degree as the artist paints them. But the elements in a still life can be moved about, added to or subtracted from, so that a good composition is developed before you even begin to draw or paint.

The principles of composition cannot be covered completely in the scope of this book, but I'd like to offer a mental checklist I use whenever I begin a new picture.

Balance

I imagine a fulcrum (the point of balance in the middle of a teeter-totter) placed at the bottom-middle of my picture. Attributing weight (or heaviness) to the darker values and colors, I arrange the picture so that it doesn't tilt to either side, but remains evenly balanced on the fulcrum. There are numerous ways to achieve balance, and no fixed rules. Sometimes one very small but intense spot of light or color can counterbalance one side of a picture.

Center of Interest

I make sure that the picture has a single focus or center of interest. The viewer's eye should not be confused by unrelated spots of value or color, but should rest on a single, dominant spot. The center of interest can be set off by making it a unique color or an especially light or dark note. I am careful not to place it too close to the edge of the picture or too close to the center. Also, I avoid placing it near the horizontal and vertical lines that divide the picture through the middle. In the example at right, the center of interest is the pink rose, which is a unique color note in the picture.

Arabesque

The arabesque refers to the decorative patterns created by the contours. I observe whether there are interesting patterns that delight the eye and lead it to the center of interest. Where a contour forms a hard, sharp angle with another contour, that point will attract the eye. So I am careful not to let

these points trap the eye somewhere other than the center of interest.

In the example, I spent a good deal of time playing with the tissue paper to find an interesting pattern that would contrast with the arabesques in the flowers. As the paper was originally set up there was a hard angle formed in the lower right-hand corner that trapped the eye, so I added a little paper across the angle to soften it.

Spotting

The spotting in a picture refers to the patterns of light and color. As I look at my composition through my viewfinder I take my eye out of focus. This eliminates detail and enables me to see the composition in terms of abstract masses and colors. This is a crucial test. I have found that if a composition looks good out of focus, it will always look good in focus. Once again, I try to avoid extreme notes of value or color that might trap the eye.

The Color Scheme

I look for colors that are pleasing together, and avoid colors that clash. For instance, I make a note of colors of a similar but slightly different hue (an olive green and a turquoise green) because they're prone to clash. I also note whether the colors are balanced in their distribution.

In the example, the petal on the tabletop was added in order to counterbalance the red in the roses in the upper part of the picture.

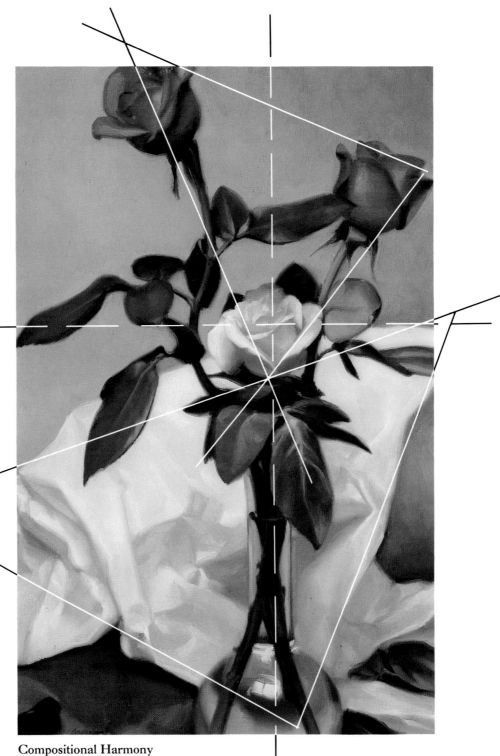

Compositional Harmony
The horizontal and vertical lines cross through the center of interest, creating comfortable, off-center divisions of the picture. The triangular motif is one of the most common methods of achieving compositional harmony, as well as the repeated motif. These two methods are used in concert in *Still Life With Three Roses*, also seen on page 40.

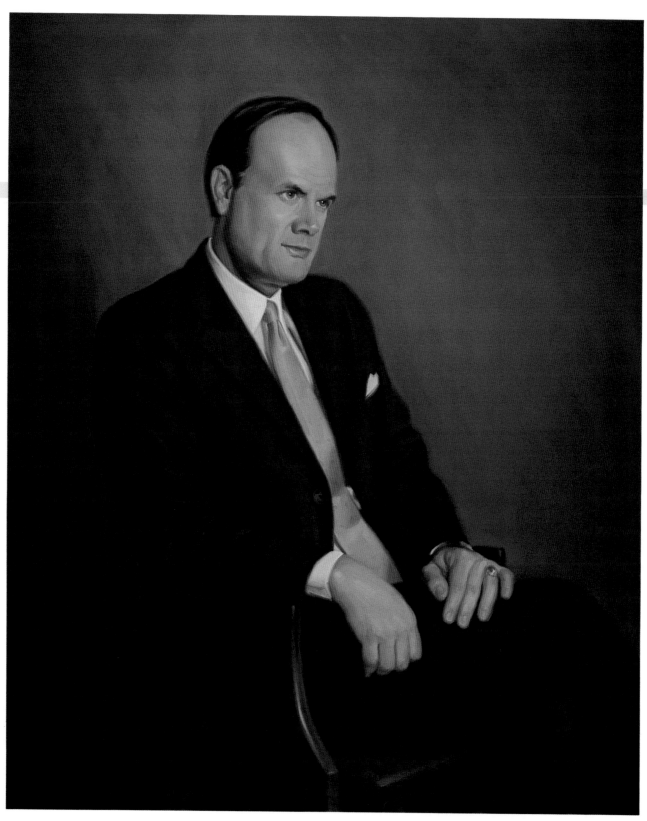

A lot of things go into making a good portrait, but I think the most important is characterization. Capturing just the right gesture and expression can speak volumes about someone. These sorts of things are also helpful in making the individual look alive, rather than like some accurately rendered waxwork.

Portrait of Grant Fair, 42″ × 34″

Mastering the Human Figure

It has been said that the great seventeenth-century painter Diego Velázquez may have used only three colors plus white when he painted his portraits. These colors were probably a red, such as burnt sienna, a warm black and a cold black. He may also have used other colors when needed, such as Venetian red and yellow ochre. But the three colors were probably sufficient to paint most of his fleshtones. The warm black would have given him a brownish quality when mixed with white and the cold black has a bluish quality. With these two blacks and what may seem a very dull-looking red, Velázquez made fleshtones that appear to have a full range of colors.

One of the biggest breakthroughs I had as a portrait artist came when I started to paint with a limited palette. My fleshtone palette is different from Velázquez's, but I arrived at it after years of noticing what colors I was consistently mixing together when I painted portraits. I found that I could mix some of these colors together beforehand, and limit the number of colors I laid out on my palette.

PREMIXING COLORS

It doesn't take a lot of colors to paint fleshtones. I find that I am able to get all the variety of color that I see with only four colors: a red, a yellow, a black and a white. Starting with six different tube colors I premix the red, yellow and black, so that they will work for the particular complexion that I am painting.

CAUCASIAN COMPLEXIONS

For a fairly standard Caucasian complexion I will make the black by mixing one part ivory black with one part raw umber. The raw umber warms up the ivory black and gives it a slightly greenish, yellowish qual-ity when mixed with white. For the red I mix one part alizarin crimson with one part cadmium red. The alizarin dominates the mixture and darkens the red considerably, but this makes it useful for work in the shadows. The cadmium, on the other hand, warms up the mixture, and allows me to get richer reds in the lights. The yellow is made of one part yellow ochre to one part lemon yellow. Once again the darker yellow ochre seems to dominate the mixture, but the cooler, yellower quality of the lemon yellow comes through in the lights where the ochre alone would be too dirty.

The one-to-one proportions that I just outlined can be adjusted depending on the complexion of the sitter. For those with darker or more olive complexions, I use a higher proportion of yellow ochre in my yellow, and perhaps darken the red a little more with the alizarin crimson, and warm up the black with just a little more raw umber. For lighter, creamier complexions I do just the opposite, using higher proportions of lemon yellow, cadmium red and ivory black.

BLACK AND BROWN COMPLEXIONS

For black and brown complexions I like to use burnt umber instead of raw umber in my black mixture. I also use a higher proportion of ochre and alizarin in my yellow and red.

What I'm describing is very different from some of the premixing

Four-Color Palette
I frequently paint portraits with nothing more than these three premixed colors plus titanium white. I determine the proportions I mix for each color by the nature of the sitter's fleshtones. For a fairly standard Caucasian complexion I will make the black by mixing one part ivory black with one part raw umber. For the red I mix one part alizarin crimson with one part cadmium red. For the yellow I mix one part yellow ochre with one part lemon yellow.

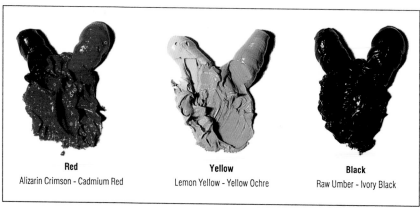

Red	Yellow	Black
Alizarin Crimson - Cadmium Red	Lemon Yellow - Yellow Ochre	Raw Umber - Ivory Black

techniques advocated by other artists. These systems often involve mixing a whole raft of colors and "graying" mixtures beforehand. I don't know all the pluses and minuses of this way of working, but its greatest advantage seems to be that because the choices of colors are so large, very little mixing on the palette is necessary. What I'm describing takes a very different approach. There may be more mixing involved, but I'm speeding up the process by limiting the number of choices I have to make.

The great advantage to my system is that it is so easy to make mixing decisions. If the color I'm mixing needs to be more yellow, there is only one choice. If it needs to be more red, there is only one choice. As you work on different parts of the figure it is very easy to maintain chromatic unity. For instance, I will always mix more black in my fleshtone when I want it to be cooler. Thus all the cool notes will be chromatically similar, no matter where or when they were added. If I had a dozen colors to choose from, I could easily forget the particular colors and quantities I used in one place. I could spend more time trying to match the color notes on both sides of the face than in developing the painting itself.

Keeping Clean

Using my method it is very important that you clean your brushes between mixing new colors. You cannot afford to contaminate your colors as much as you could if you had a broader spectrum of colors to work from. For instance, if I had a full-strength cadmium yellow and lemon yellow on my palette, I could always reach for those to make a fleshtone I was mixing yellower. However, because I don't have those at hand to brighten up my muddy color, I have to clean my

brush in order to get the full richness of the yellow that I do have.

I am convinced that this is the biggest obstacle to using a limited four-color palette. Not wanting to clean their brushes thoroughly between notes, artists just find it easier to have extremely intense colors on their palettes. However, there are some tricks to having clean brushes for mixing colors. One is just to have a lot of brushes, and to use the same brushes for the same basic notes. Another trick is to have a large bucket for cleaning brushes. Adopting these kinds of procedures can make an enormous difference in

your work.

When I paint portraits I work alla prima, using the same basic procedure I outlined in the last chapter for painting still lifes. Occasionally I will stretch the canvas larger than I think the final composition will be. This gives me some room for error, in case I later discover the figure is too far to one side or the other. When I finish the picture I can just restretch the canvas to the best size for the composition.

As with the still life, I block out the drawing with a wash and then mass in the values starting with the darks and moving toward the lights.

Cleaning Brushes
A technique I use for keeping my brushes clean is to put a wire strainer (like you use for straining spaghetti) in the bottom of a bucket. I fill the bucket with paint thinner deep enough to cover the bristles of brushes when they're set in it. It is easy to keep brushes clean by swirling them against the strainer, which allows the paint sediment to drop to the bottom. I wipe the brush against a thick rag or paper towels which I keep next to the bucket. I use a rag in my hand only to squeeze the last bit of thinner out of the brush, using a rag that's thick enough so the thinner doesn't come in contact with my hand.

SHADOW TECHNIQUE

In terms of alla prima technique, many of the same principles apply that I mentioned in the last chapter. When painting shadows I try to use as little paint as possible and grind it into the canvas to avoid too much texture in the brushwork. At first I ignore the variations within the shadow and paint it everywhere with a single, solid color, usually on the dark side of what I'm actually seeing. This is because the lightest notes tend to be in the middle of the shadow, and it is easier to add lighter variations later than to darken the shadow along its edges.

Along the shadow line, I allow my shadow color to overlap slightly into the halftone area. When it comes time to mass in the halftone, I overlap slightly into the shadow I've already painted. I want to make the halftone slightly cooler along the edge where it meets the shadow. When the primarily black shadow note mixes with the primarily white halftone, it gives me this effect.

HALFTONE

I use one value to paint in all the shadow area of the face. The same principle applies to the light area of the face (often referred to as the halftone). There is usually so much variation in halftone that a single value to represent it all can create more problems than it's worth. But the principle should be applied as well as it can be. You want to use as few broad values as possible so that you can start from a point of unity. Usually I start with about three broad values: 1) the lightest halftone area furthest from the shadow, 2) the warmer halftone transitions to the shadow—usually seen on the upper half of the face, such as the nose and forehead, and 3) the cooler halftone transition to the shadow that I usually see on the lower half

Portrait in One Sitting
It is particularly challenging to paint alla prima portraits of women and children like this one, which I did in essentially one sitting. The transitions in the fleshtones must be very delicate and you cannot get away with the fractured brushwork that can be perfectly acceptable in portraits of men. I start by painting the entire light area of the face with a single color. Any variations in color and value are then added by carefully mixing them into what I've already put down.

Portrait of Jane Zuelke, 24" × 18"

of the face and neck.

In painting halftone, start from a point of too much unity. Detail can always be added by working color into what you've already applied, or by adding transparent notes.

TRANSPARENT NOTES

When I initially mass in the painting I tend to work slightly darker and more opaquely than I want the final picture to be. I can then create variations in the form in some places simply by pulling off some of the paint I've already applied. Of course, by making the paint more transparent I am not only lightening it, I'm making it richer and warmer in color. So I try to limit transparent technique to those places in the halftone which can use more color, such as above the cheeks, around the eyes, and on the lips. Extremities, such as ears, nose and fingers, also tend to have more color, so transparent technique can be useful when giving these their final touches.

OPAQUE HIGHLIGHTS

I always paint the highlights last with the thickest, most opaque touches of paint in the picture. One of the difficulties in doing this, however, is that highlights tend to be very precise, hard-edged shapes. Where the light is reflecting off glossy surfaces—which is often the case on the nose, and is always the case in the eye—the highlight takes on the same shape as the light source. Since I paint using natural light, I see little square highlights, the same shape as the window.

I am not always successful in applying a nice little stroke that is both thick enough and square enough to represent the highlight. So I sometimes paint it slightly larger than I want it. I then square off the highlight by working the surrounding color notes up to it.

Paint Children in Fleeting Moments

As is typical of children, it was difficult for this sitter to stay in pose for more than a second at a time. This is one reason why it is so helpful to develop efficient techniques for painting portraits. By using broad swatches of value to capture the big impression first, you can then add details as you see them during those fleeting moments when the child is in pose.

Portrait of Danielle Faribault, 31″ × 23″

Using a Three-Color Palette

Everything in this portrait, even the background, was painted
with the three premixed portrait colors plus white. It was painted
in three sittings. With the first sitting, lasting about five hours,
I blocked in the body and finished the head. In the other two
sittings, lasting about two hours each, I finished the body and
the background.

Portrait of D. Raymond Frisby, 48″ × 35″

[A] There is often more than one highlight in an eye. The primary highlight is usually found on the pupil, and because of the highly reflective surface of the eye, it takes on the shape of the light source somewhat. Another, much smaller highlight, can be found where the liquid collects along the inside lower lid. The membrane in the corner of the eye also reflects its own highlight.

[A]

[B] One of the most defining characteristics of the nose is where the plane on the side of the nose meets the plane of the face. The plane on the nose is going to have a distinctly different value, even though at first glance it might be indistinguishable from the plane on the face.

[B]

[C] In painting the smaller shadows and accents in a face, it is important not to make them too dark. Notice how the cheek line that comes out on the right side of the nose was painted a rich red. There is a lot of light being reflected back into this little shadow.

[C]

[D] The shadow side of the face was mixed with yellow, red and a little black. For the cooler notes and accents I added more black. For the areas with reflected light I added more red.

[D]

[G] For the light side of the face, I usually began with white mixed with a little yellow. I would then add various amounts of red depending on how warm I wanted the note to be.

[G]

[F] Sometimes I add a touch of black to my fleshtone for the particularly cool notes often found in the bearded area of men.

[F]

[E] I was careful to bring color into the upper lip, which was entirely in shadow. Since the lip itself has a darker value than the surrounding fleshtone, it's easy to make this note too dark and black. This color is always much richer when you look at it out of the corner of your eye. This is also the case with the shadow in the nostril.

[E]

Two Modes of Seeing

As I've mentioned before, when you initially cover the canvas you want to analyze what you are seeing in terms of abstractions, taking your eye out of focus so that you can interpret the figure as simple broad masses of light and color.

This is especially helpful when painting the human figure, because we are full of prejudices about what the various shapes and colors of the human figure should be. Our tendency is to want to paint the local color, so that Caucasians become a sort of uniform pinkish beige. We also have a tendency to paint the tactile quality of shapes, giving length, for instance, to those things we are actually seeing foreshortened. But when we take our eye out of focus and interpret the figure as some sort of oddly shaped vegetable, we are able to dispense with our tactile and color preconceptions, and are more likely to capture the true colors and shapes.

It is this method of analysis that you bring to bear when initially applying paint. Your objective is to capture the broad shapes and gestures, as well as the broad colors and values that you are seeing.

However, as the painting is worked to greater finish, this self-assumed naivety about just what it is you are painting will start to become a hindrance. This is because the shapes that define the human form are so subtle. In painting a landscape, for instance, it doesn't matter that much if a tree is not painted exactly as it looks. A tree shaped one way is just as good as a tree shaped another. But the human form is not so forgiving. If the contours and variations of value that delineate the structure of bone and muscle beneath the flesh are not drawn in precisely the right place and with the proper subtlety, the figure will look unnatural or grotesque.

So after the basic value masses are established, you must occasionally shift gears to a different mode of analysis. Instead of ignoring the fact that it is a human figure, you must bring to bear a specialized knowledge of just what it is and who it is you are painting. You must apply your understanding of how the human figure is put together, and what precisely is happening beneath the surface of the skin. And you must apply what you know about the personality of the person you are painting.

The great challenge when doing

The Planes of the Face

The front of the face is on an entirely different plane than the side of the face. In this portrait, this division is neatly expressed by the shadow line. It begins on the outer side of the eyes and angles out a little around the zygomatic arch (cheekbone). It then angles in toward the dimples around the mouth, then in a little more, until it ends at the bottom of the chin. The full portrait appears on page viii.

this is to maintain that larger visual impression that you had when you were looking at the figure more abstractly. In terms of anatomy, the tendency is to focus too much on whatever detail you are trying to delineate, and to overexaggerate the variations in the form. In terms of personality, the tendency is to overexaggerate the characteristics that make your sitter unique. In either case you are diverging from nature, making your subject too much of a caricature or cartoon.

And yet at some point the purely abstract impressionistic approach must make way for this specialized knowledge and insight.

I recommend becoming familiar with human anatomy by studying some of the texts designed for that purpose. One of the classics on the subject is Paul Richer's *Artistic Anatomy*, published by Watson-Guptill (1971, and 1986 paperback). A challenge I gave myself as a student was to memorize plates from this book. This helped me in both learning anatomy and developing my memory retention.

Painting the Mouth

When I'm painting a mouth I look for the three roundnesses, which were particularly apparent in this portrait of Jane Zuelke, as seen on page 110. One of these is in the upper lip. From the two corners, the upper lip presents a flat plane until it reaches the middle where it bulges into a roundness. In the lower lip I imagine two such marbles about an inch apart across the middle of the lip. I try to capture the distinction between the flat plane of the lip as it begins at the corners, compared to the rounding, bulging quality in the middle.

Painting the Eyes

At the inner corner of the eye, where the lower and upper eyelids meet, a separate membrane casts a rich pink color. This membrane also softens the transition between the surface of the eye and the eyelids, so it's important not to overmodel the detail there. The lower eyelid is a difficult line to paint. It tapers to a point and changes character before it reaches the inside corner. On the outside corner, it meets the upper eyelid as if it were wrapping around the orb of the eye. In painting the lower eyelid in this portrait, *Christ the King*, pictured on page 11, I did not try to use a single stroke to define both edges of the shape. Rather I painted up to the edge. I first painted the eyelid where it meets the surface of the eye, and then painted the plane of the face where it meets the eyelid. That way I dealt with only one edge at a time.

A Man's Hands

The extremities of hands, such as knuckles and the tips of fingers, tend to be ruddier than the other flesh notes. The squareness of the knuckles and bones expresses the age and masculinity of these hands. This painting also appears on page 4.

A Child's Hands

Children's hands are chubbier than adults'. The ends of the fingers in this hand are even a little redder than they normally would be since this girl was leaning on her hand and the blood was collecting there. Her full portrait can be found on page 111.

A Woman's Hands

Women's hands taper more than men's hands, and are not as bony. I like to position a woman's hands so that this length and elegance are shown to best effect. This portrait appears on page 122.

CAPTURING PERSONALITY

It is very easy as an impressionist artist to get so wrapped up in the process of painting that you ignore the subject. In fact it has been said of some impressionist painters that they didn't really care much about the subjects they painted at all. Monet, for instance, painted a whole series of pictures of a shapeless mound of hay in an empty field. One suspects it was the sheer dullness of the subject that attracted him. That way he could show off his skill at capturing the subtleties of color, light and atmosphere, as seen at different times of day, making those things the real subject of his picture.

When it comes to painting portraits, however, you can't treat your subject as just another object reflecting light. Before you even begin to paint you have to decide what it is you want to say about the personality of your sitter. You must then have your sitter assume a variety of different poses in a variety of different lights to see what works best. An individual's personality is expressed in extremely subtle ways. A slight tilt of the head or droop of the shoulder can say an enormous amount about the person.

When portrait sitters first come to my studio to pose, I usually tell them to sit and relax while I get my materials ready. While I'm doing this, I chat with them, offer them coffee and other refreshments, show them recent paintings, etc. In the process I observe how they sit when they are relaxed, how they use their hands and hold their head. Of course, as soon as I ask them to pose, all their natural gestures vanish. But by using my previous observations, I am able to coax them into poses that do look natural for them.

Either using gestures I've seen them use, or ones I've just asked them to assume, I will eventually fix

Making Hands Expressive
Hands can express a great deal about the personality of the sitter. The relaxed gesture of these hands, along with the slight slouch of the shoulders and tilt of the head (seen in the full portrait on page 106), work together to suggest the relaxed self-confidence of this man.

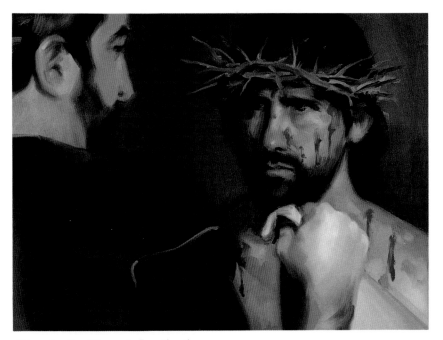

Allow for the Viewer's Imagination
When portraying a personality which is open for interpretation, a loose and spontaneous technique is sometimes helpful. Not only does it allow you to capture something closer to your own initial response to the subject, it also allows a little more room for the viewers' imagination to play. They are freer to fill in the detail according to their own emotional response.

Christ Stripped of His Garments, 14″ × 19″

upon a gesture which I think will make a nice portrait. From that point on I have to keep that gesture in my mind. As I paint the picture, the sitter will not always maintain precisely the gesture I envisage. I may only be able to get them to assume one small part of the gesture at a time. So I have to go beyond being an Impressionist, ignore what I'm seeing, and make my picture conform to my original vision.

The same principle must be applied to the expression. Now I usually don't ask a lot from my sitters when it comes to the expression. I don't like to paint big smiles, for instance. In my portraits the mouth is either closed or slightly open, and from time to time I will request that my sitter hold it in that position.

But I don't just paint what I see. For most people, when they just sit and stare into space their faces sag. I will often talk to my sitters to keep their faces animated, but this means that there is no static expression for me to fix upon and paint. In painting the expression I have to interpret what I see. I have to decide what

Posing Your Sitter
Grant Fair was a very patient and relaxed sitter. But my sitters are never able to hold precisely the expression and position I envisage for their portraits. I have to keep my vision for the portrait in mind as I paint, and coax my sitters into assuming the proper position for whatever part of the portrait I am painting.

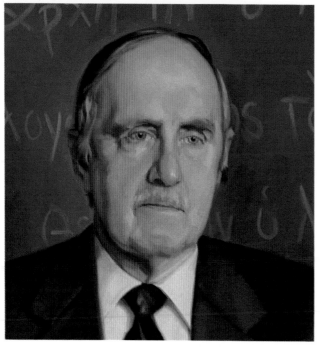

Facial Expression
The modern custom of having your picture taken with a big smile sometimes works against the portrait artist. I think a truly distinctive portrait is most often made by capturing the serious or thoughtful side of the subject's personality as in this detail of a *Portrait of Walter Dunnett* as seen on page 4.

turn of the lips I want, how deep to make the cheek lines, how narrow or wide the eyes. All these things speak to the personality I am trying to achieve, and I have to keep that goal constantly before me as I paint them.

It is this process of making choices that is the most mysterious and most difficult to teach. I have seen portraits painted with enormous skill—almost technically perfect—but which are dissatisfying all the same. These portraits fail because they don't portray the individual. Sometimes they lack the character or personality of the sitter, and sometimes they simply lack any sense of life at all.

As a naturalist painter this is an easy trap to fall into. I have to continually remind myself that I have two essential goals in painting portraits. One is to capture the broad visual impression, and the other is to make some sort of statement about the personality of the sitter. I must always keep both goals in mind if I am to arrive at a successful portrait.

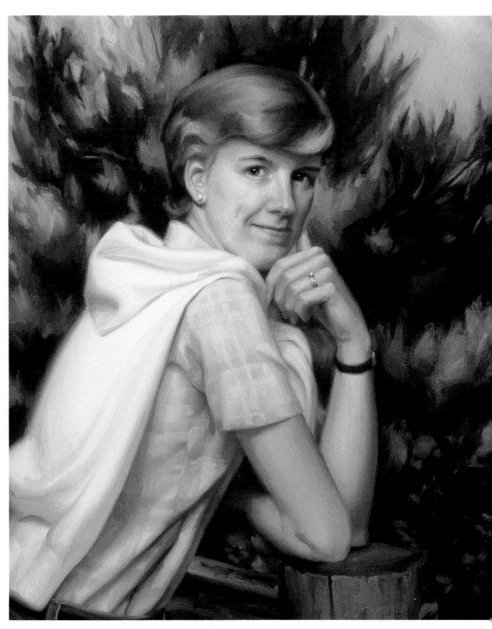

Consider the Difficulty of the Pose

What may look like a very simple and natural pose can sometimes be very difficult to hold. I probably wouldn't have asked anyone else to assume such a pose, but I wanted to try something unique when I painted this portrait of my wife. It turned out she could only hold that exact pose for a couple minutes at a time, and she demanded neck massages to compensate for her efforts.

Portrait of Arlene Dedini Anderson, 23" × 29"

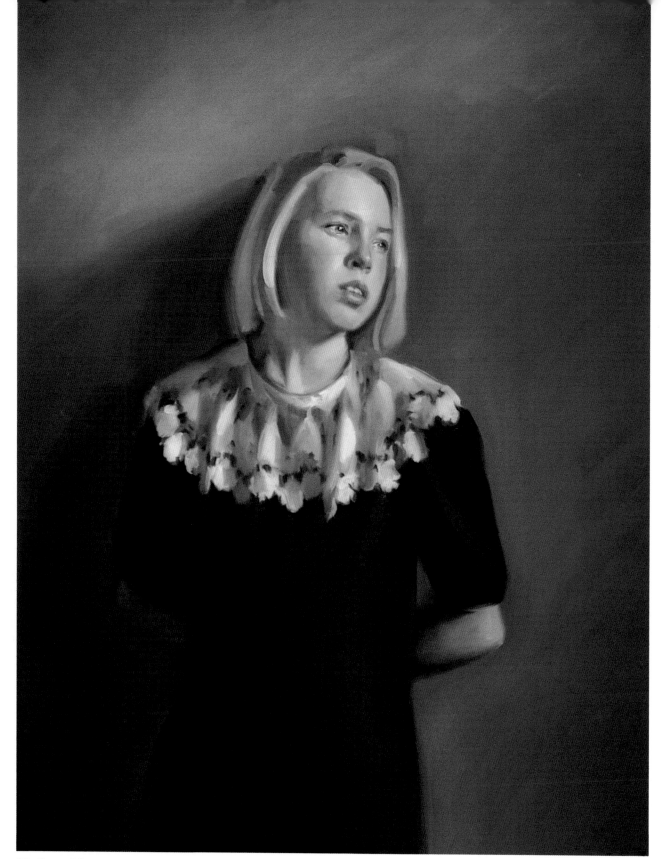

Finding a Natural Pose for a Child
Children often look stiff and unnatural when posed sitting in a chair, so after trying a variety of seated poses, I finally pulled away the model stand and had the model lean against the wall. When she turned her head toward the window, the pensive personality I was trying to capture suddenly came through.

Portrait of Jennifer Shegos, 40″ × 30″

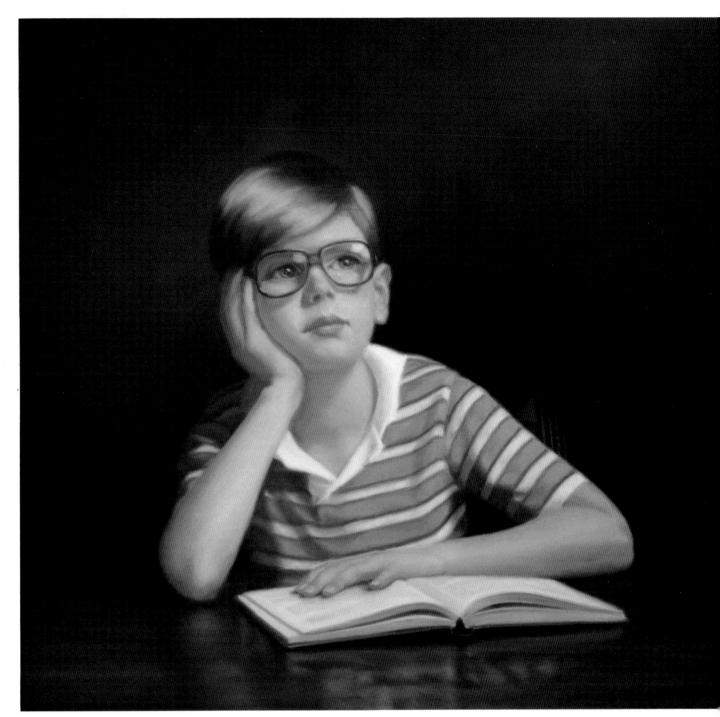

Paint Children Doing Something
I try to make my portraits of children as informal as possible. If the parent commissioning it agrees, I will try to make the portrait something of a genre scene, capturing the child as if engaged in some everyday activity.

Tommy, 30" × 32"

Keep the Sitter's Expression in Mind

With this portrait I was most concerned that the model's face be animated. Since there was no way for her to keep this smile for more than a moment at a time, I had to continually make choices: how deep I wanted to make the cheek line, for instance, or how wide or narrow the eyes. Ignoring what I saw, I had to keep in my mind's eye what I wanted the expression to ultimately look like.

Portrait of Shari Ober, 34″ × 26″

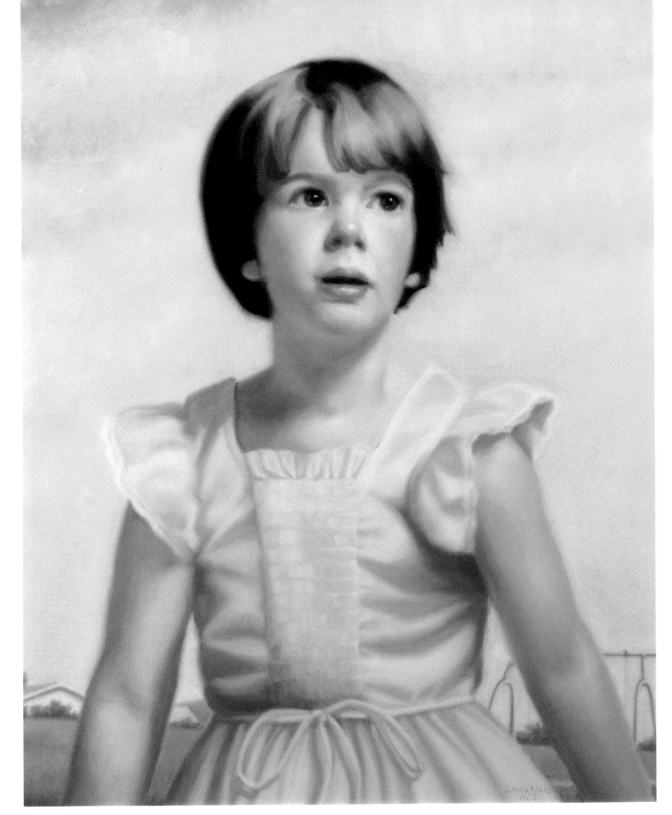

Tell an Interesting Story

It doesn't take an elaborate pose or a lot of background elements to tell an interesting story. There was something about this little girl that demanded that I place her outdoors, with her arms swinging, looking with wonder at the world around her. A swing set can be seen in the background because she was the sort of child that delighted in such simple pleasures. The broad, blue sky behind her suggests that she is living on an airier plane, and that her concerns are not yet too strongly centered on this earth.

Anne, 28″ × 22″

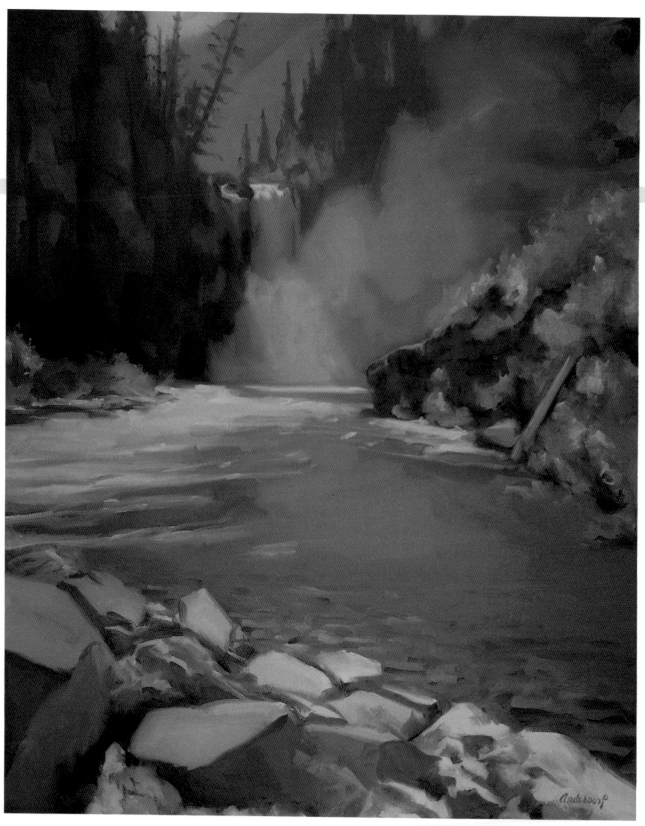

A great master's style is not something I have ever just tried to imitate. Rather, I have drawn upon the knowledge that the masters have built up over the centuries and have used it to explore new styles of my own.

Misting Falls, 30" × 24"

Conclusion

The emphasis of this book has been on learning how to see and reproduce the visual world around us. But one of the most important ways we can learn this skill is by studying the work of the great masters. They were "great" often because they discovered some new element of nature that no one had ever seen or painted before. And what they discovered became part of the vocabulary of all subsequent artists, whether these artists chose to use it or not. Rembrandt, for instance, discovered new aspects of the shadow, painting them more luminous and reflective than any painter had previously done. Ever since, young painters have been enjoined to make their shadows "flat and liquid." And though some artists may choose not to, because it defeats some other objective, it is now an aspect of visual truth which all classically trained painters can draw upon.

A great master's style is not something we should just try to imitate, however. Mere imitation usually results in failure—something far worse than the original. It is, rather, the lore of knowledge that the masters built up over the centuries that we should draw upon. This lore can open our eyes to the beauty and mysteries of nature and provide us with the tools to go in whatever direction we might choose.

Broadly speaking, the artistic objectives of traditional painters have fallen into one of three categories. We are primarily interested in the decorative, narrative or impressionist potential of painting.

The decorative encompasses interesting and harmonious color schemes, value patterns and contour arabesques—in short, all those abstract elements that make up composition. Ingres, Whistler and Puvis de Chavannes were artists for whom the decorative side of painting was of primary importance.

The narrative impulse is best illustrated by such artists as David, Meissonier and Gérôme. They delighted in telling a story or recreating a scene from the past. Most decorative and narrative painters fall somewhere between the extremes of these examples. Michelangelo and Raphael, along with most of the high-Renaissance masters, were either decorative painters with a strong narrative bent, or vice versa.

The impressionist impulse can be seen, of course, in the great French Impressionists of the late nineteenth century. Such artists as Monet and Sisley were captivated by the explosion of broken color created by sunlight in nature, and wanted to reproduce exactly what they saw. But as I mentioned before, other, earlier artists have also come to be known as Impressionists. Velázquez, Vermeer and Chardin were all artists captivated by the beauty of nature. They wanted to reproduce exactly what they saw: the play of light on various textures, the effect of atmosphere on light, and the broad visual impression.

My own direction is primarily impressionistic. I delight, more than anything, in capturing the scene before my eyes as it is described by light. In making the human figure my primary subject, however, another dimension is added to my painting—a narrative dimension. It is inevitable that I use gesture and composition to shed light on the character of the person I'm painting—in short, to tell a story.

There are an infinite number of directions we can take these skills. And whatever direction we might choose to take them is as legitimate as any other. The important thing is that we follow the example of artists like Jean François Millet—that we carefully employ the language of the visual world and be true to the thing that originally stirred our heart to become an artist.

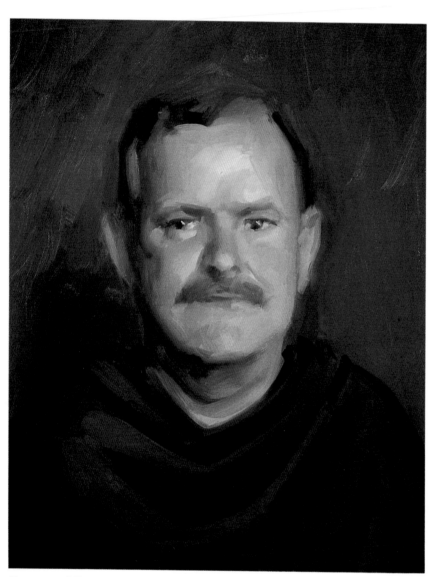

Contrast of Opaque and Transparent Brushwork
I have not seen transparent color used a great deal with alla prima technique, and yet I have found the transparent properties of certain pigments enormously useful in my own work. I have also found that I like the contrast between opaque and transparent brushwork; it seems to add interest to the surface appearance of the picture. I like to think that I add something new to the traditions of the great masters by exploring this type of technique.

Portrait of Michael Heitz, 16" × 13"

Achieving the Rich Colors of Nature

People often think that because the colors Impressionists use
are so bright and intense, they are unnatural. Impressionists,
however, are actually slaves to nature. It is impossible to achieve
the richness of color that is seen outdoors in any way other than
to use bright, primary notes.

Misty Mountains, 22" × 28"

Painting on Assignment

For this book cover assignment, I was sent the manuscript with no other instructions than to make three simple sketches for the editors' consideration. They chose the sketch they preferred, along with suggested modifications, which I then transformed into a finished oil painting. I don't look on these kinds of assignments as something distinct from "fine art." I think that it is more appropriate to look on illustration as another genre of painting, like landscape is a genre, or still life is a genre, or imaginative mural painting is a genre. The Old Masters frequently worked within constraints similar to illustration: They were commissioned to paint particular mythological or biblical scenes for particular architectural settings. The ability to create "fine art" within such constraints is the real mark of professionalism.

Crocodile Burning (Book cover), 24″ × 19″

The Focus in a Still Life
More than any other genre, still life painting is for artists who
are interested in naturalism and abstract composition. In a still
life the focus of the picture is on the richness and variety of color,
on the play of light on different textures, and on the use of com-
position to create satisfying harmonies.

Still Life With Gardener's Tools, 18" × 22"

Capturing the Light

I delight most in capturing the scene before my eyes as it is described by light. Success as a painter has come to me as I have learned to carefully employ the language of the visual world.

Autumn Chrysanthemums, 24″ × 18″

The Key to Success

If there is one rule to follow in pursuing a career as a painter it is this: Have fun. I think it is the artists who are having the most fun that paint the pictures we like to look at. It is those who take it too seriously and are burdened by their own deficiencies that fail. If you are painting in order to change the world, then you are probably going to be disappointed. But if you're painting for fun, you have success no matter what else happens, and the tiredness you feel at the end of the day is a pleasant tiredness.

Painter Resting, 16" × 20"

Index

More Great Books for Painters!

Capturing Radiant Colors in Oils — Vitalize your paintings with light and color! Exercises will help you see color relationships and hands-on demonstrations will let you practice what you've learned. #30607/$27.99/144 pages/222 color illus.

Welcome To My Studio: Adventures in Oil Painting with Helen Van Wyk — Share in Helen Van Wyk's masterful advice on the principles and techniques of oil painting. Following her paintings and sketches, you'll learn the background's effect on color, how to paint glass, the three basic paint applications, and much more! #30594/$24.95/128 pages/146 color illus.

Timeless Techniques for Better Oil Paintings — You'll paint more beautifully with a better understanding of composition, value, color temperature, edge quality and drawing. Colorful illustrations let you explore the painting process from conception to completion. #30553/$27.95/144 pages/175 color illus.

Bringing Textures to Life — Beautifully illustrated step-by-step demonstrations will teach you how to add life and dimension to your work as you render dozens of textures in oils. #30476/$21.95/144 pages/500+ color illus./paperback

Painting Flowers with Joyce Pike — Popular artist/instructor Joyce Pike will help you make your florals absolutely radiant with 240 color illustrations and 15 demonstrations! #30361/$27.95/144 pages/240 color illus.

Foster Caddell's Keys to Successful Landscape Painting — You'll paint glorious landscapes with practical advice from this master painter. Plus, dozens of helpful hints will help you solve (and avoid!) common painting problems. #30520/$27.95/144 pages/135 color illus.

Basic Oil Painting Techniques — Learn how to give your artwork the incredible radiance and depth of color that oil painting offers. Here, six outstanding artists share their techniques for using this versatile medium. #30477/$16.95/128 pages/150+ color illus./paperback

Painting Landscapes in Oils — Master painter Mary Anna Goetz shows you the methods and techniques she uses to paint landscapes alive with light and color. #30320/$27.95/144 pages/200 color illus.

Oil Painting: Develop Your Natural Ability — No matter what your skill level, you'll develop you own style as you work through 36 step-by-step exercises with noted artist Charles Sovek. #30277/$29.95/160 pages/220 color illus.

Joyce Pike's Oil Painting: A Direct Approach — As an oil painter, you know that one of the biggest problems is keeping colors clean and pure. Joyce Pike shows you how to overcome this problem and paint more beautiful oils. #30439/$22.95/160 pages/190 color illus./paperback

Painting the Beauty of Flowers with Oils — You'll get clear, insightful instruction on everything from effective use of materials to choosing flowers. Plus, you'll see handy tricks used to tackle the most troublesome parts of still lifes. #30325/$27.95/144 pages/195 color illus.

The Complete Oil Painting Book — Hone your skills and polish your oil painting techniques with the 32 step-by-step demonstrations presented in this comprehensive guide. #30111/$29.95/160 pages/256 color illus.

Oil Painter's Pocket Palette — Full color reproductions of an array of color mixes will help you choose the perfect colors to convey a sense of tone, mood, depth and dimension. #30521/$16.95/64 pages

The Acrylic Painter's Pocket Palette — Take the guesswork out of mixing colors — before the caps come off the tube. You'll see 1,632 mixtures, each as a dry glaze, a 60-40 mixture, the mixture tinted white and applied as a watercolor wash. #30588/$16.95/64 pages/4-color throughout

Painting with Acrylics — 25 full-color step-by-step demonstrations will show you how to tackle a variety of subjects from the figure to portraits and more! #30264/$21.95/176 pages/paperback

The Complete Acrylic Painting Book — You'll master the techniques of working in this beautiful and versatile medium with 32 detailed demonstrations and loads of helpful advice. #30156/$29.95/160 pages/256 color illus.

How To Paint Trees, Flowers & Foliage — You'll create balanced scenes full of wonderful greens as you learn to keep foreground flowers from dominating, represent a tree without painting every leaf, and more! #30593/$27.95/144 pages

Painting with Passion — Discover how to match your vision with paint to convey your deepest emotions. With step-by-step instructions, fifteen accomplished artists show you how to choose a subject, and use composition, light, and color to suffuse your work with passion. #30610/$27.95/144 pages/225 color illus.

Enrich Your Paintings with Texture — Step-by-step demonstrations from noted artists will help you master effects like weathered wood, crumbling plaster, turbulent clouds, moving water and much more! #30608/$27.95/144 pages/262 color illus.

Enliven Your Paintings with Light — Sharpen your light-evoking abilities with loads of examples and demonstrations. #30560/$27.95/144 pages/194 color illus.

Strengthen Your Paintings with Dynamic Composition — Create more beautiful paintings with an understanding of balance, contrast and harmony. #30561/$27.95/144 pages/200 color illus.

Dramatize Your Paintings with Tonal Value — Make lights and darks work for you in all your paintings, in every medium. #30523/$27.95/144 pages/270 color illus.

Energize Your Paintings with Color — Create paintings alive with vivid color and brilliant light. #30522/$27.95/144 pages/230 color illus.

How To Paint Living Portraits — Make your portraits come alive! 24 demonstrations show you great techniques for all mediums. #30230/$28.99/176 pages/112 illus.

Painting Vibrant Children's Portraits — Let a master painter, Roberta Carter Clark, teach you how to capture the charm and innocence of children in any medium. #30519/$28.95/144 pages/200+ color illus.

100 Keys to Great Pastel Painting — Discover how to revitalize overblended colors, tone down bright ones, achieve a variety of special effects, and more! #30591/$16.95/64 pages

Pastel Interpretations — Explore dozens of techniques as you observe Foster Caddell, Frank Zuccarelli and 16 other artists render their interpretation of the same photo. #30516/$28.95/144 pages/275 color illus.